T0124720

THE URBAN FORAGER

WROSS LAWRENCE

Photography by Marco Kesseler

HOXTON MINI PRESS

GO WILD IN THE CITY

Foraging provides a brilliant escape from the stress and humdrum of city living. It forces us to slow down and take in the landscape, and it's a great opportunity to explore the areas we often overlook. Once you start foraging, you may find yourself spotting a perfect dandelion patch from the top deck of a bus, or a luscious honeysuckle bush while out walking the dog. It becomes involuntary, you notice things you may not have before. It's also completely free!

We all used to be foragers before the invention of the supermarket: the city has taken us away from our roots. So I invite you to reconnect to a wild world, one filled with colour, excitement, muddy hands, vitamins, minerals, flavours and aromas. In these pages I tell you how to find 32 plants in any urban environment across the seasons. Each one is accompanied by a simple yet tasty recipe.

I hope this guide encourages you to release your inner neanderthal in the green corners of your city, ignite your inner foodie in the kitchen and, most of all, have fun.

Wross Lawrence, professional forager

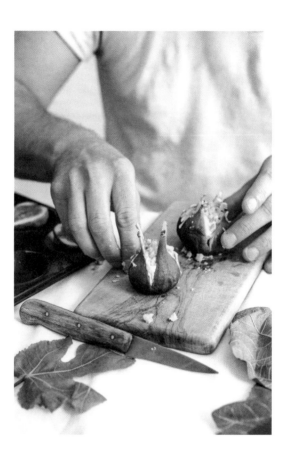

CONTENTS

SPRING

SUMMER

AUTUMN

WINTER

TIPS FOR URBAN FORAGING

It's surprisingly easy to forage in the city but it also takes a little patience and care: qualities that a busy urban life don't always teach us. You may not immediately find what you are looking for and be aware that seasons don't follow a perfect timetable. But slowing down and reconnecting with nature is part of the fun.

BECOME A STUDENT Read the description and examine the photos in this book carefully. Pay attention to the scent, touch and the shapes of leaves. Feel free to crush a bit of the plant and smell it but don't nibble as an ID check – the wrong plants could give you a upset stomach. Use as many sources as possible (internet, books, knowledgeable friends).

ONLY EAT IF YOU'RE CERTAIN Most plants in the city are safe to pick but there are a number of poisonous doppelgängers (*see* pp.184–189). Be sure you have the right plant before eating it.

WASH PLANTS THOROUGHLY Give your plants a good rinse when you get home and be sure to check for bugs too.

AVOID POORLY SPECIMENS If it's wilting, browning or blackening, it's not going to taste good. Leave the plant alone... and hope it gets well soon.

SAME-DAY COOKING I recommend picking your ingredients and cooking with them the same day for the freshest flavour. However, most ingredients will keep for up to a week in the fridge, except flowers, which only last a few days.

TRY NOT TO TRESPASS Private land is out of bounds unless you have consent. Some public parks are protected too. If you're not sure, contact the owner or park manager to check. If you want to know all the details of the official legislation it's best to look online.

RESPECT MOTHER NATURE Be gentle with your new plant friend, meaning don't uproot the entire thing. That's illegal! Also, don't take the whole lot of the good stuff (e.g. all the berries on a bush). Instead, leave some grub for your fellow foragers, including the birds.

AVOID IF PREGNANT It's advised that women should not eat wild food while pregnant in case of any unexpected harmful effects.

WHERE TO FORAGE
IN THE CITY

PARKS It's no secret that most parks have a fantastic selection of trees, young and old. Some even have a woodland habitat where you can find many different food items in one place. The edges of parks are also worth scanning, particularly for climbers and flowers.

WATERWAYS The ground surrounding these liquid highways is often rich in nutrients, plus these areas aren't as well maintained as other public spaces so wild plants get a chance to thrive. Waterways on the outskirts of the city tend to back on to scrubland – also great for pickings.

CEMETERIES These spiritual homes to the departed tend to bear logs and branches that have been left to rot, as well as compost heaps – wild plants love both of these. It is a happy coincidence that a lot of the species that grow in cemeteries have edible flowers and fruits too.

STREETS AND PAVEMENTS Embankments, roadsides, pathways, even cracks in the pavement: plants can spring to life in these unexpected places. Plants that overhang onto the street from someone's garden are fair game – just be sure not to pick anything on the owner's side of the fence.

FORAGER'S TOOLS

Bare hands and deep pockets will suffice but some of these extra items can come in handy. You may want to recruit a tall friend to pick fruit up high, otherwise an umbrella with a hook will do.

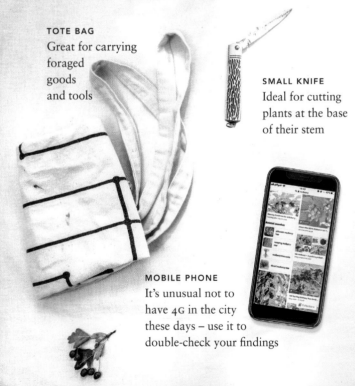

TOTE BAG
Great for carrying foraged goods and tools

SMALL KNIFE
Ideal for cutting plants at the base of their stem

MOBILE PHONE
It's unusual not to have 4G in the city these days – use it to double-check your findings

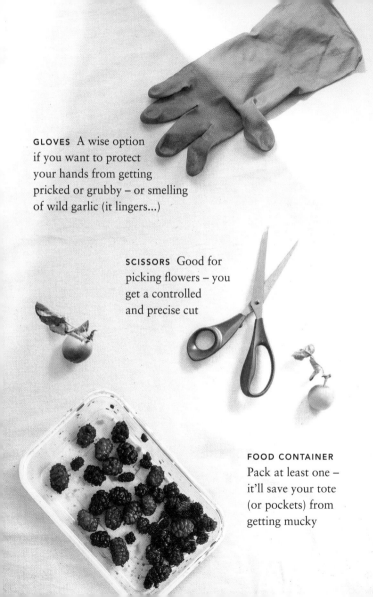

GLOVES A wise option if you want to protect your hands from getting pricked or grubby – or smelling of wild garlic (it lingers...)

SCISSORS Good for picking flowers – you get a controlled and precise cut

FOOD CONTAINER Pack at least one – it'll save your tote (or pockets) from getting mucky

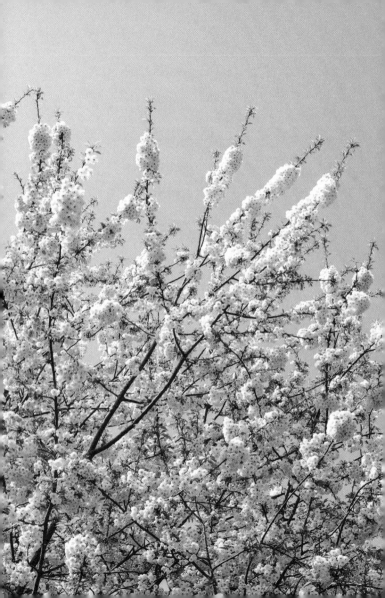

SPRING

With trees in full bloom and days a little
longer, spring is the ideal time to begin
foraging. Flowers, leaves and shoots make
tasty ingredients in light dishes such as
salads, tarts and summer rolls.

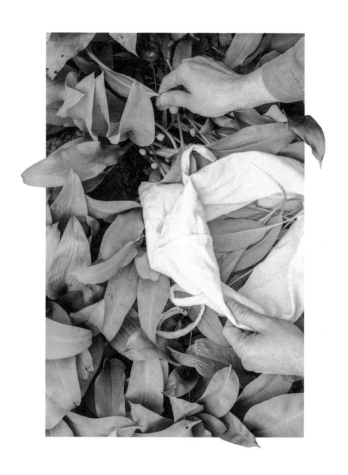

Wild garlic, p.28

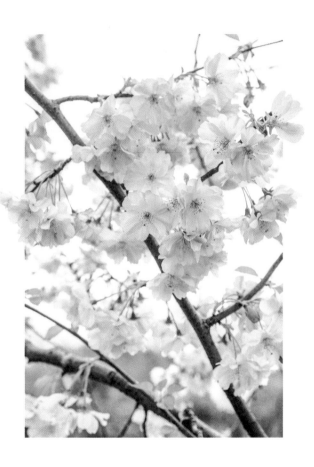

Cherry blossom, p.32

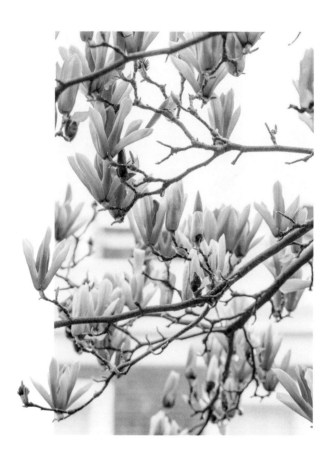

Magnolia, p.36

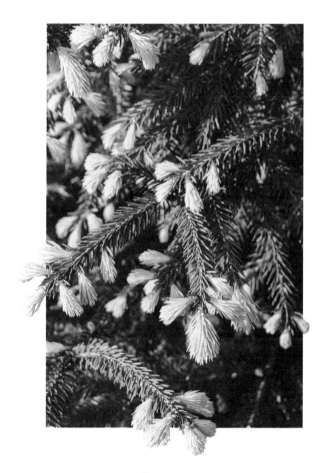

Spruce, p.40

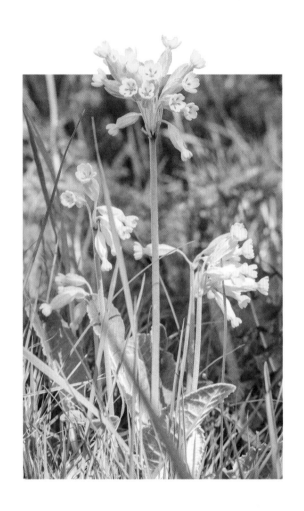

Cowslip, p.44

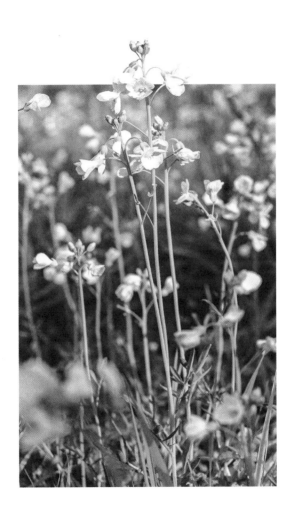

Lady's smock, p.48

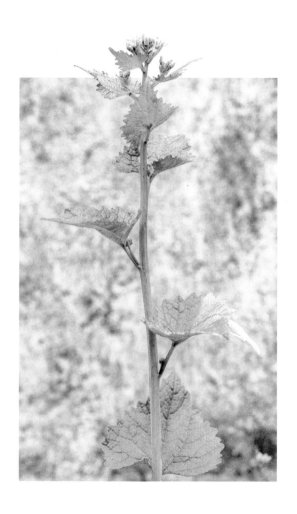

Jack-by-the-hedge, p.52

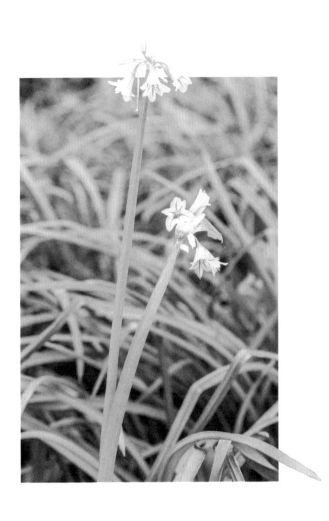

Three-cornered leek, p.56

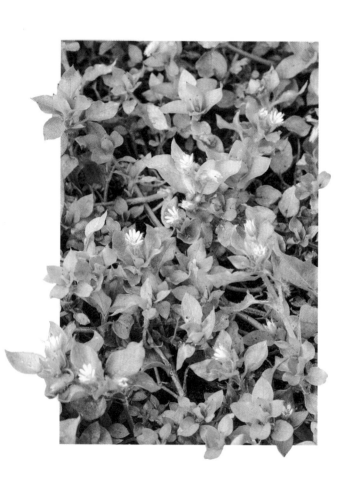

Common chickweed, p.60

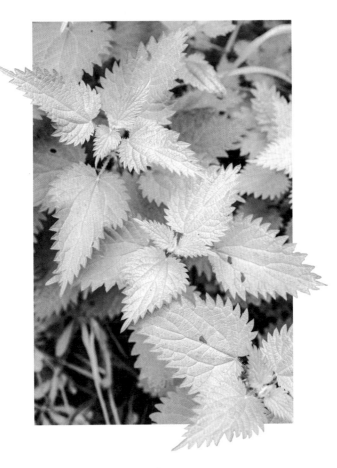

Nettle, p.64

WILD GARLIC

Allium ursinum

AVAILABLE March–May

WHERE Cemeteries, parks, woodland

CAUTION This plant can grow alongside a poisonous one called lords and ladies (*see* p.189)

Quite possibly the Godfather of all wild greens, the Steve Jobs of the onion family, The Beatles of foraged foods, wild garlic is the one to find as it's delicious, vibrant and versatile. A keen nose won't have any difficulty in sniffing out this plant's heady onion/garlic aroma. It always seems to grow in the most beautiful areas too, making it a joy to go looking for.

IDENTIFICATION Ranging from 2–30 centimetres in height, wild garlic's bright green tapered leaves are best picked by the stem a couple of centimetres from the ground. Be careful not to uproot it, as you'll definitely want to return to the same spot to pick a few of its tall white flower heads for a salad garnish when they start to bloom, and even collect some green, spherical seed pod clusters at the end of the season for pickling.

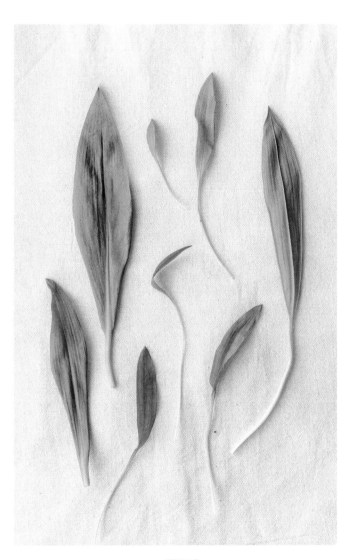

SPRING

WILD GARLIC AND
GOAT'S CHEESE TARTS

Wild garlic adds a delicious flavour to all sorts of dishes. I've suggested this one as it's especially good with goat's cheese.

MAKES 6

1 parsnip
20g butter
375g shortcrust pastry
50ml milk

100g wild garlic
2 egg yolks
100g goat's cheese

Peel and chop the parsnip into 2cm chunks, drizzle with oil and season on a baking tray, then place in the oven at 180°C for 30 minutes. Take a standard 12-cup muffin tin, grease 6 of the individual cups with butter and line with the pastry. Prick the pastry before placing in the oven to blind bake for 7–10 minutes. While this is cooking, mash or blend the cooked parsnip, adding the milk as you go until it's reached a smooth consistency. Take the wild garlic, set 6 leaves aside then chop the rest and stir into the parsnip mixture. Add the egg yolks and seasoning to the mix, making sure it's combined well before decanting into the blind-baked pastry cases. Top with sliced goat's cheese and the wild garlic leaves and return the tray to the oven for a further 10–12 minutes until the pastry is lightly golden.

ALTERNATIVE IDEAS Blitz wild garlic into a pesto, add chopped leaves to a risotto or throw it in a spring salad.

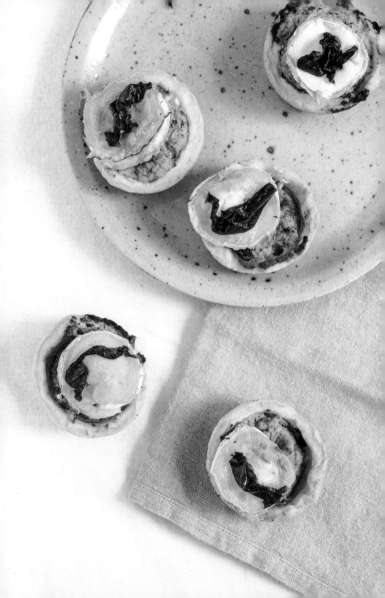

CHERRY BLOSSOM

Prunus serrulata

AVAILABLE March–May

WHERE Parks, commons, roadsides

CAUTION Can be confused with flowering dogwood, which is edible but unpalatable. Use multiple sources for an extra ID check.

When the cherry trees flower, filling the air with pink confetti, it really does signify the end of winter. Picking the bright blooms against a blue sky makes me feel springier than Bruce Springsteen or Jerry Springer doing handsprings. It's only around for a couple of weeks, so make sure you grab it while you can. In fact, the Japanese see cherry blossom as a metaphor for the fleeting nature of life itself.

IDENTIFICATION With its large, pink blossoms and distinctive brown tiger-striped bark, the cherry tree is hard to miss during springtime. The flowers usually hang in clusters of between 2 and 6. The leaves develop after the tree has finished blossoming.

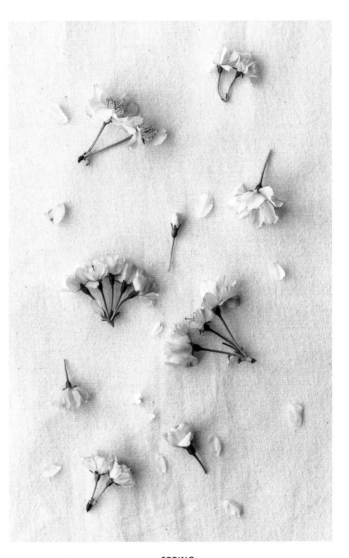

SPRING

SALT-CURED CHERRY BLOSSOM SHORTBREAD

This recipe involves a simple curing process that takes three days but leaves you with a big batch of gorgeous almond-tasting blossoms. These give biscuits a wonderful flavour and there will be plenty left to use in other recipes too.

MAKES 12–15

200g cherry blossom buds
Large open blossoms, to serve
150ml ume plum vinegar
100g coarse sea salt

125g unsalted butter,
* softened*
55g caster sugar
180g plain flour

In a bowl, massage the salt into the cherry blossom buds and liquid will begin to ooze from them. After a couple of minutes, transfer the buds to an airtight jar, cover them with plum vinegar and close the lid. Leave for 3 days. Then, rinse thoroughly to remove any salt and delicately squeeze out the liquid, being careful not to crush the buds completely. Bake in the oven for 2–3 minutes at 100°C to dry them out. Chop the butter into chunks and put in a mixing bowl with the caster sugar. Mix with a wooden spoon to a creamy consistency, then stir in 20g of the dry, chopped cherry blossoms before sieving in the flour, mixing little by little. Store the remaining blossoms in an airtight container, ready to use in other recipes (they are particularly good for decorating cakes and cocktails). Flour a work surface and roll out the dough to 2cm thick. Cut into finger-lengths, around 3cm wide, and place in the fridge for 30 minutes before baking at 180°C for 15–20 minutes. To serve, sprinkle with caster sugar and fresh blossoms.

MAGNOLIA
Magnoliaceae

AVAILABLE March–June
WHERE Parks, roadsides
CAUTION Its berries are poisonous

A magnolia tree in full bloom is hard to miss – it's a real show-stopper. However, not many people know that you can eat the big petals of this elegant spring flower. It tastes very similar to how it smells, with sweet citric notes and a hint of ginger. So give each one a good sniff and pick the petals that smell great. The best way to eat them is pickled (*see* p.38).

IDENTIFICATION There are over 200 varieties of magnolia trees, which grow from 3–15 metres in height. The bright white petals of the flowers change colour during their growth, to a light pink or purple, yet they remain white underneath (as pictured in the photo opposite). You can pick them when they are still white on top or wait for them to show more colour. They can be both evergreen and deciduous. The evergreens have long smooth dark green leaves which are lighter underneath and taper at each end; the deciduous varieties' leaves won't have unfurled yet. The individual petals range from about 8–30cm long and have a wonderful spoon-like curve to them.

SPRING

PICKLED MAGNOLIA NOODLES

It takes a week, but invest the time in pickling some magnolia petals and you'll end up with a big batch of tangy delights that can be used in numerous dishes.

SERVES 2

500g magnolia petals
200g granulated sugar
300ml rice vinegar
1 tsp salt
100g rice noodles
2 tbsp vegetable oil
1 clove garlic, finely sliced

10g coriander
1 white onion, finely sliced
1 red chilli, finely sliced
1 spring onion, finely sliced
100g mange tout
100g baby sweetcorn
Lime wedges to serve

Bring the sugar and rice vinegar to the boil in a pan. Remove from heat and pour over the salt and petals in an airtight jar so the petals are completely covered with liquid. Allow to cool before closing the lid. Leave for a week to steep. To make the noodles, cover them in boiling water to soak as per cooking instructions. Heat the oil in a large frying pan or wok on full heat until hot, then add the garlic, coriander stalks, white onion and red chilli. Fry for 2 minutes, constantly stirring, then add the chopped spring onion, mange tout and baby sweetcorn, halved lengthways. Fry for a further 3–5 minutes then add 50g of magnolia petals. Remove the noodles from the water and chuck them in the pan. Stir through the coriander leaves and serve with a wedge of lime.

ALTERNATIVE IDEAS Use the remaining pickled petals to liven up a salad or add to a strong cheddar sandwich.

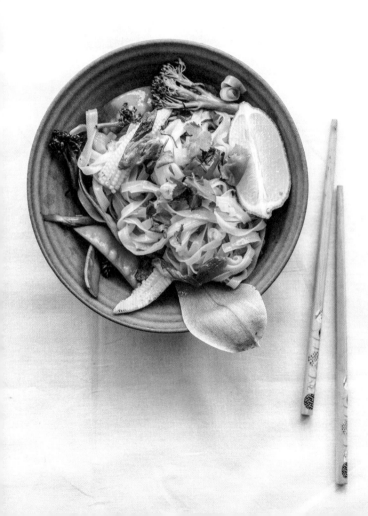

SPRUCE

Picea

AVAILABLE April–May
WHERE Parks, woodland
CAUTION Not to be confused with the highly toxic yew (*see* p.187)

Hugely popular in the timber industry for its beautifully grained wood, the spruce tree has been a part of our daily lives for centuries. Back in the day, a beer made from its twigs was used as a popular cure for scurvy but the plant was overlooked in the culinary world until fairly recently. Like many wild plants, it's very high in vitamin C and rich in potassium and magnesium too.

IDENTIFICATION A Christmas tree, for want of a better description, that grows 2–60 metres tall. The easiest way to identify a spruce tree is to check the needles. They will be three-dimensional, firm, pointy and will dent your fingertip if pressed. They grow from every side of the branch and in every direction. Fir trees and yew trees have flat, two-dimensional needles that grow only on the sides of the branch and not at the tip, are very flimsy to the touch and a much darker green. In the spring the new tips of the spruce are very distinct – bright green with the appearance of witches' broom-ends and a scent of fresh lemons.

SPRING

SPRUCE TIP HONEY

This is a vegan 'honey' that has citrus, sweet and woody notes. It's made with just three ingredients and can be put together in minutes. It's the waiting three weeks while the steeping takes place that is the hardest part of this recipe. Fantastic in tea, on yogurt, with cheese or even in a cocktail.

MAKES 200g
250g sugar
200g spruce tips
1 lemon

Pour a layer of sugar into a sterilised, airtight container, top with a small handful of spruce tips, then a slice of lemon and repeat this process until the container is full, trying to make sure all the levels are even. Close the lid and leave on a sunny windowsill for 3 weeks. The citric acid will be released and melt the sugar. Remove lid and empty contents via a sieve lined with a muslin cloth into a new container. This should keep for a year at least.

ALTERNATIVE IDEAS Add some spruce tips to a jug of iced water with cucumber slices for a refreshing, foresty drink or infuse in hot water to make a tea.

COWSLIP

Primula veris

AVAILABLE April–May
WHERE Parks, woodland, embankments
CAUTION Can be mistaken for oxlip, which is also edible

This taller and multi-headed cousin of the much-loved English primrose used to be far more common than it is now and would bloom abundantly all over meadows in the spring. It is still fairly easy to find in the city though. The little yellow flowers have a citrusy taste and can really perk up a spring salad.

IDENTIFICATION The cowslip is a distinctive-looking plant. It's numerous egg yolk-coloured bell-shaped flower heads stand proudly above the grass, sometimes up to 25cm in height, bobbing in the wind atop a slender soft-haired stem. The leaves form a rosette at the base of the plant. They're tough in texture with wrinkled edges and narrow towards the stem.

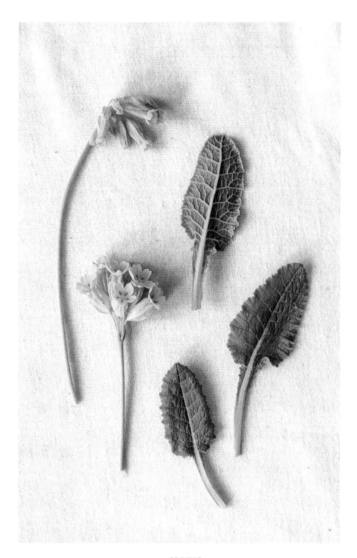

SPRING

COWSLIP SUMMER ROLLS

This fun and colourful recipe requires no cooking at all, just a bit of practice handling the rice paper wraps, but by the third one you'll have it down!

MAKES 8–12

12 rice paper sheets	*50g cowslip flowers*
1 avocado	*1 cucumber*
20g coriander	*1 carrot*
1 red chilli	*1 red pepper*
50g cowslip leaves	*100g purple cabbage*

Finely slice the avocado, chilli, cabbage, cucumber, carrot and pepper. Chop the coriander and cowslip leaves. Half-fill a pan larger than your rice paper sheets with lukewarm water. Completely submerge a sheet in the water and watch it disappear! Leave for 10–15 seconds then lay it on a chopping board (not a wooden one because they really stick to them). Now layer on the chopped ingredients in a vertical line down the middle of paper sheet in any order you desire, making sure to leave a good gap at each end. When happy with your assemblage, fold in the top and bottom of the rice paper, so that it covers what will be the ends of your roll. Then, spin it round and roll it up, tucking the veg in as you go to make it as tight as you can. It's a bit fiddly and sticky but you'll soon be an expert.

ALTERNATIVE IDEAS Garnish any salad with cowslip leaves and flowers, or pour boiling water over flowers to make a tea – great before bedtime as a sleep-inducing tonic.

LADY'S SMOCK
Cardamine pratensis

AVAILABLE April–May
WHERE Parks, meadows, woodland, roadsides, embankments

This unbelievably elegant wildflower – also sometimes called the cuckooflower – has a wasabi-like heat to it. The phrase 'float like a butterfly, sting like a bee' comes to mind.

IDENTIFICATION If you spot some pale pinky-purple dots scattered above a vibrant green open grassland, you may have found your lady's smock. On closer inspection you will notice that the leaves at the base of the plant are a lot rounder than the ones found higher up. Going up the stem, the leaves become thin, straight and are often less abundant. The green central stem is topped with a head of numerous small flowers that face in all directions. Each flower has 4 overlapping petals and a yellow centre.

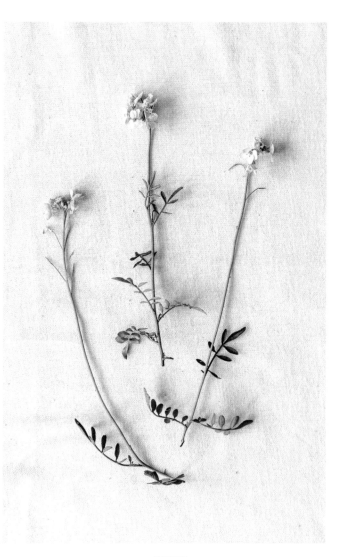

SPRING

LADY'S SMOCK FATTOUSH

A monster salad with a nice heat that will leave you feeling satisfied and healthy.

SERVES 4

For the salad:
100g lady's smock leaves
and flowers
2 pitta breads
1/2 a cucumber
6 radishes
4 spring onion
2 baby gem lettuce
16 cherry tomatoes

20g parsley
20g mint
2 tsp ground sumac

For the dressing:
125g natural yoghurt
Juice of 1/2 a lemon
25g chopped mint

Roughly chop all the salad ingredients except the pittas and sumac and toss together. Toast the pitta breads before chopping them into chunks and mixing them in too. Mix the dressing ingredients together then drizzle on top of the salad. Sprinkle with ground sumac, season to taste and serve.

ALTERNATIVE IDEAS Upgrade your sandwich by adding a few sprigs of lady's smock (it's a good alternative to cress). Also great when blended with chickweed pesto (*see* p.62).

JACK-BY-THE-HEDGE
Alliaria petiolata

AVAILABLE All year round
WHERE Roadsides, woodland, heathland

This plant gets its name from English folklore whereby 'Jack' was used to describe something or somebody 'common'; it is also called a little less imaginatively 'garlic mustard' due to its incredible flavour. This unusual member of the cabbage family is a biennial, meaning it takes two years to complete its life cycle, which is anything but common.

IDENTIFICATION It grows up to a metre in height with a pencil-thin stalk that is straight as an arrow. You might notice one or two dotted about or a whole hedge full. Its shield-shaped leaves with dramatic, serrated edges grow out of different sides of the stalk, getting smaller as they reach the top, where clusters of 4-petaled white flowers with a green centre sit atop like a halo. The leaves can take on yellow and deep reddish hues depending on their age, but the subtle smell of onion and garlic given off when they're crushed between your fingers never changes.

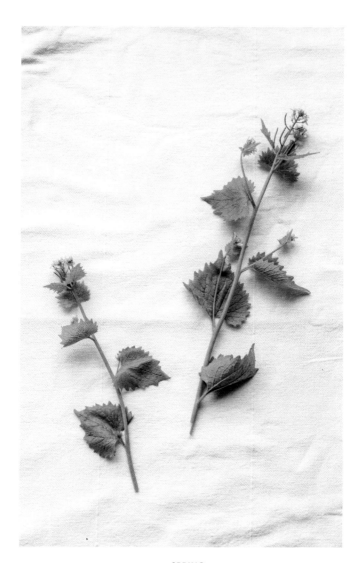

SPRING

JACK-BY-THE-HEDGE PIE

You'll be amazed that the only onion/garlic flavour in this dish is coming from the Jack leaves – it really is the star ingredient in this light, oozy and crunchy spring-time pie.

SERVES 2

2 slices of bread
40g butter, melted
200g mushrooms, sliced

500g Jack-by-the-hedge leaves
75g blue cheese, chopped
1 packet of filo pastry sheets

Cut the bread into 2cm chunks and dry fry in a pan on a low heat until browned and crisp. Remove and crush into crumbs. Fry the mushrooms in almost all the melted butter (save a little for brushing the pastry later). Once the mushrooms have cooked through, add the chopped Jack-by-the-hedge, season and stir until wilted. When liquid begins to form in the bottom of the pan, add the blue cheese, stir until melted, then add the breadcrumbs and stir until the liquid is absorbed. Remove from heat and allow to cool. Lay one of the filo sheets diagonally into your pie dish, brushing butter over any bit not overhanging the dish. Then layer on another sheet at a different angle and repeat until you have 4 layered buttered sheets. Now add your filling and spread evenly before folding over the overhanging pastry sheets one by one to form a lid, buttering as you fold them. Place in an oven preheated to 180°C for 30 minutes, remove and enjoy.

ALTERNATIVE IDEAS Use Jack-by-the-hedge in place of watercress in a soup or blitz it up with oil and vinegar to make a salad dressing.

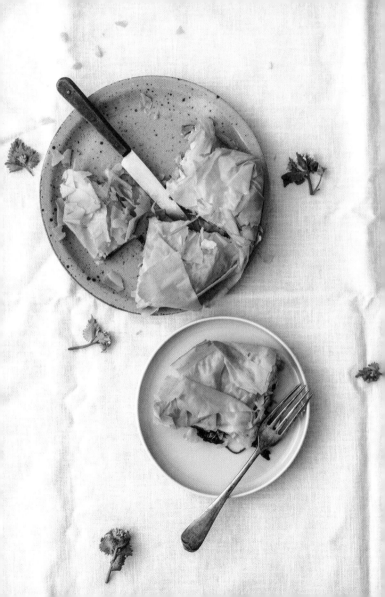

THREE-CORNERED LEEK

Allium triquetrum

AVAILABLE All year round

WHERE Parks, woodland, waste ground

CAUTION Not to be confused with the poisonous lily of the valley (*see* p.188)

This relative of wild garlic (*see* p.28) has a more subtle flavour than that of its bolder brother, and so lends itself to a wide range of dishes. It has a soft onion-and-garlic taste and smell and is simple to find due to its pretty flowers. It is a joy to collect as its juices are used in insect repellent, so there's no need to worry about creepy crawlies when picking this fine-leafed friend.

IDENTIFICATION Three-cornered leek grows in vast clusters, all falling over each other, so you'll never find just one or two dotted about. Their long, thin leaves look at first like giant blades of grass, except for the distinctive triangular shape of the stem, which gives it its name. You can distinguish this plant from its lookalikes by the onion/garlic smell it gives off when picked – apart from few-flowering garlics, nothing else smells like it. Three-cornered leek has a cluster of white trumpet-shaped flowers hanging from each stem. Each has six white petals with a thin green line running down the centre of each – a beautiful sight that's a thrill to discover.

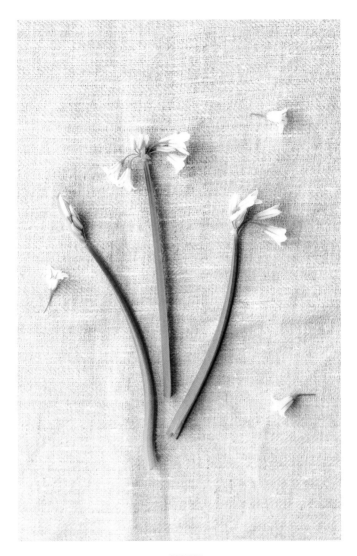

SPRING

THREE-CORNERED LEEK
AND POTATO SOUP

A perfect rustic spring soup that is rich in flavour and colour and uses just a few simple ingredients.

SERVES 2

300g new potatoes
2 tbsp olive oil
100g parmesan
25g butter

1 white onion, sliced
500g three-cornered leek, chopped
750ml vegetable stock

Slice ¾ of the way down the width of your potatoes, hasselback-style, leaving gaps between each cut – as if you were making a miniature garlic bread. Place them on a baking tray, sliced side up. Drizzle with olive oil and grate the parmesan on top. Cook in an oven pre-heated to 180°C for 30–35 minutes. You'll blitz these cheesy potatoes later but the cutting method is worth the small effort to ensure the parmesan falls into the gaps and toasts nicely. Melt the butter in a saucepan, add the onion and three-cornered leek and season. Cook for 3–5 minutes until soft and wilted. Add the stock to the pan and leave to simmer for 15–20 minutes. Once the potatoes are ready, empty them straight from the baking tray into the soup, scraping off all the crispy cheese stuck to the tray. Remove from heat and mash with a masher until you reach your desired lumpiness, or blend if you prefer a smooth soup.

ALTERNATIVE IDEAS Mix some sautéed three-cornered leek into a bowl of buttery gnocchi. Also great in guacamole and pesto.

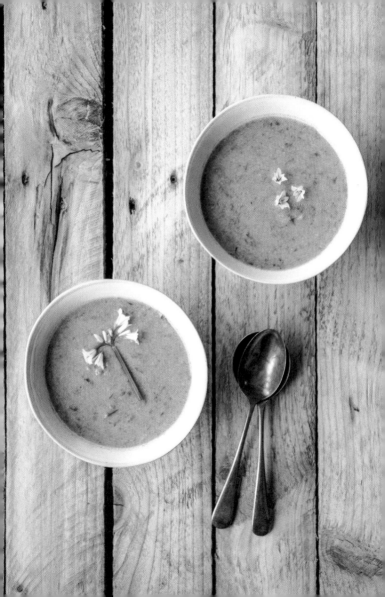

COMMON CHICKWEED

Stellaria media

AVAILABLE All year round
WHERE Roadsides, parks, waste ground
CAUTION Do not consume if pregnant or allergic to the daisy family. Not to be confused with poisonous scarlet pimpernel (*see* p.184)

Loved for its sweet and aromatic flavour, chickweed is a wild microgreen success story: you'll find it all over the city, all year round. It's a common medicinal herb applied in Chinese medicine and is used to treat diseases of inflammation. Back in the day, it was sold by Victorian street traders as pet bird feed (hence the name 'chickweed').

IDENTIFICATION If you see a sprawling dense carpet of luscious green with intermittent white flecks hiding in the shade, chances are you've got yourself a bed of chickweed. It will be made up of interwoven thin individual succulent stems that can grow up to 60cm in length. The leaves that run along the stem can vary in size, but they are uniformly smooth, oval shaped and grow close together in parallel pairs climbing the stem, forming a cross shape as they get to the tip of the plant like a micro herb compass, usually topped by a central flower resembling a small daisy. A great ID check is the stem. Common chickweed has very fine hairs running down only one side of it.

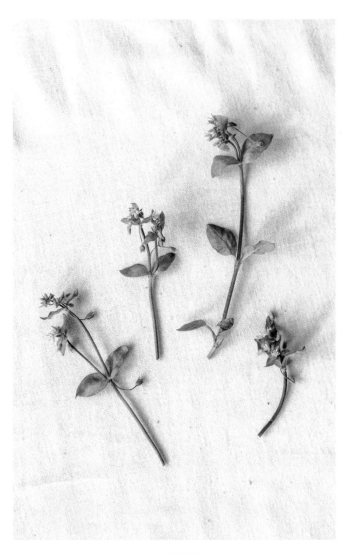

SPRING

COMMON CHICKWEED PESTO

Dismissed by gardeners and allotment holders as a common weed, this recipe showcases this tasty and nutritious plant's qualities. This pesto is vibrant, earthy, fresh and straightforward to make.

SERVES 4

50g walnuts
80g chickweed
50g parmesan

150ml extra virgin olive oil
2 garlic cloves
Juice of 1/2 a lemon

Place all the ingredients in a blender and whizz until desired texture is achieved, then season. If you don't have a blender, dice all ingredients and beat in a pestle and mortar. Serve with your favourite type of pasta.

ALTERNATIVE IDEAS Try putting chickweed in a salad, an omelette or a sandwich.

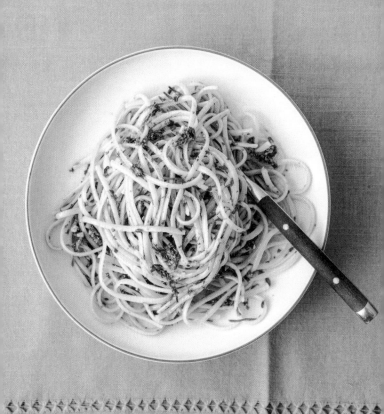

NETTLE

Urtica dioica

AVAILABLE All year round

WHERE Pathways, woodland, cemeteries, heathland, commons, marshes, parks

CAUTION Wear thick gloves when picking to prevent getting stung

This unsung star can be found all over a sprawling metropolis, adding a little bit of stingy jeopardy to our daily lives. Nettles are surprisingly tasty and can be used in place of spinach in lots of recipes. They are packed with vitamin C, iron and protein too. Just bear in mind that nettles growing right by the path may have been visited by a four-legged local...

IDENTIFICATION Now, I know the idea of picking anything that stings is not the most appealing thought. However, it does make it easy to identify – the plant's dark green, serrated, shield-shaped leaves that grow on the green/purple stem are covered in fine hairs. This is what causes the stinging sensation when they touch the skin, so it's a good idea to wear thick gloves to pick the leaves, or get a friend to do it for you! I simply pick the tip of each plant with one hand inside a cotton tote bag, then drop it into another. Nettles often grow to about 2 metres in height but the smaller, younger leaves found at the top are the best to eat.

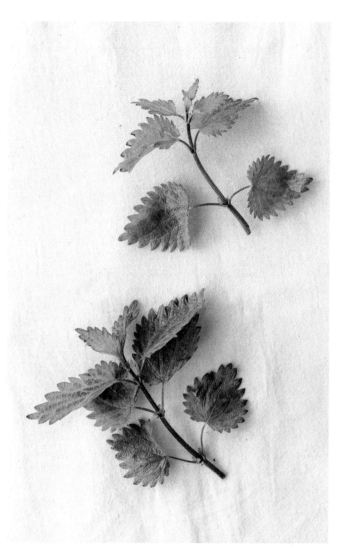

SPRING

NETTLE RAVIOLI WITH SAGE AND NETTLE BUTTER

So tasty and simple, this will become a staple in your repertoire.

SERVES 2

200g 'oo' flour, plus a bit extra for cooking surfaces
3 large eggs
100g nettles, washed under hot then cold water

50g ricotta
1/2 a lemon
100g butter
Large handful of sage leaves
6 small nettle leaves

Sieve the flour into a mixing bowl. Make a well, and crack in 2 eggs. Mix, adding a little of the third egg if it doesn't come together. Knead on a work surface for 7–10 minutes until smooth. Wrap in clingfilm and rest in the fridge for 1 hour. Boil the nettles, then squeeze out the excess water. Chop finely, add to the ricotta and grate in the zest of 1/2 a lemon. Cut the dough into quarters and roll with a rolling pin on a floured work surface until you can see your fingers through it. Use a 6cm cutter to cut out rounds. Place 1 teaspoon of the nettle mixture in the centre and egg wash around it, then top with another round. Squash down the edges, making sure it's sealed and there aren't any air bubbles around the filling. Place onto a floured baking tray and cover loosely with a damp tea towel while working on the rest. Cook the ravioli in a large pan of salted boiling water for 3–5 minutes until tender. Melt the butter in a frying pan over a high heat, add the sage and small nettle leaves. Cook until crispy and the butter is browned. Drain the pasta, plate up and drizzle over the buttery, leafy goodness.

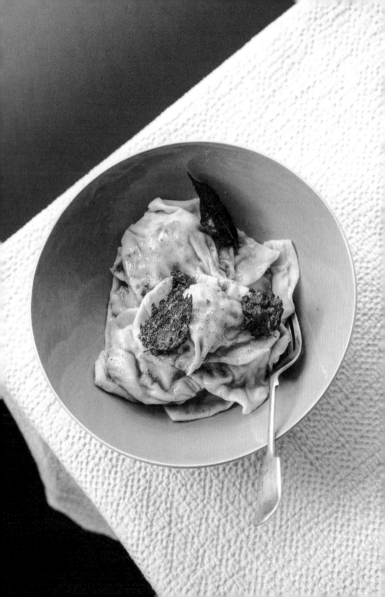

SUMMER

A season of abundance, summer is all about fruits, flowers and fragrant herbs. Make the most of the good weather and balmy evenings with a post-work foraging spree. You might find an exciting ingredient to add flourish to your al fresco dinner.

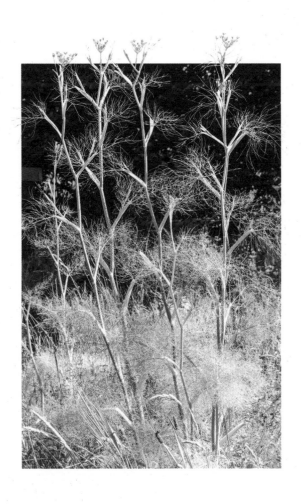

Wild fennel, p.80

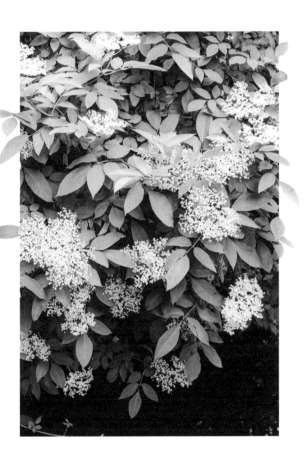

Elderflower, p.84

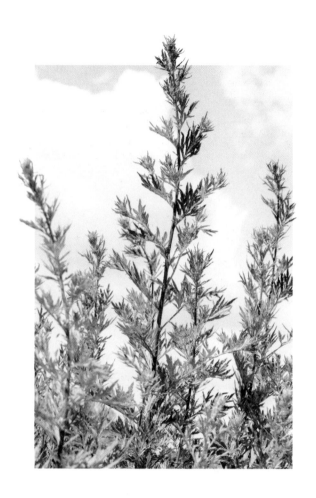

Mugwort, p.88

Pineapple weed, p.92

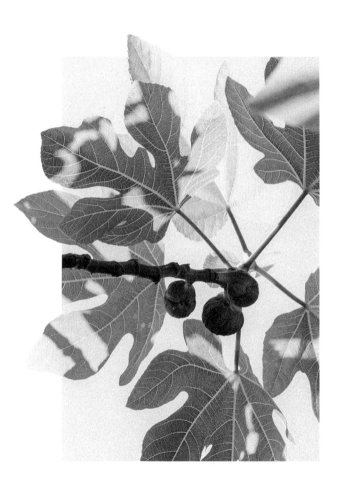

Wild fig, p.96

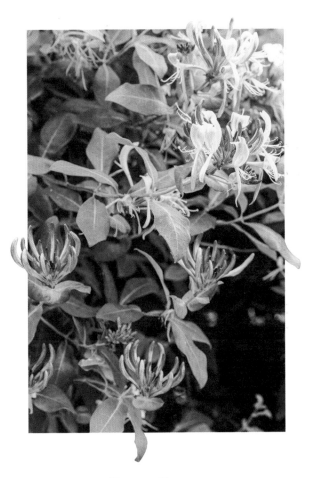

Honeysuckle, p.100

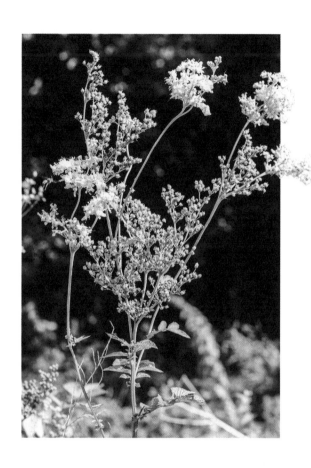

Meadowsweet, p.104

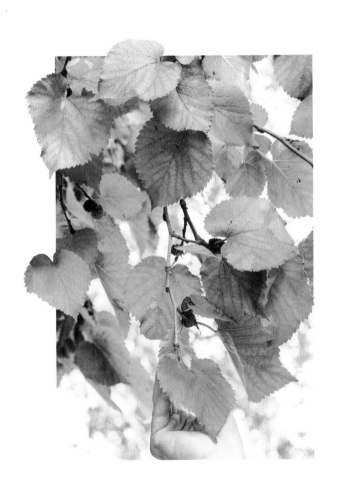

Mulberry, p.108

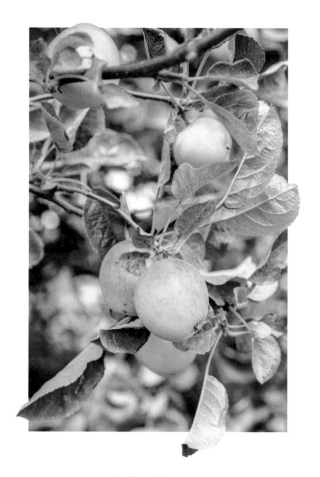

Crab apple, p.112

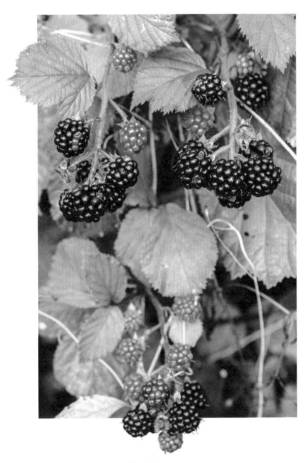

Blackberry, p.116

WILD FENNEL

Foeniculum vulgare

AVAILABLE March–September
WHERE Roadsides, parks, waste ground
CAUTION Do not uproot the bulb (it's not edible, unlike other fennel)

This robust wild plant, known as the 'spice of angels', thrives in areas where most plants can't due to a number of factors: it has a tap root, meaning it sits firmly in any ground, it grows tall so gets a lot of sunlight, and its seeds are easily spread by wind, water and birds.

IDENTIFICATION Wild fennel's finger-thick main stems grow up to 2 metres tall. It's smooth and pale green, with smaller branches shooting off in opposite directions along the length. The flowers are made up of lots of bright yellow balls forming an umbrella shape at the end of a curved green stem. The leaves are feathery looking, not dissimilar to dill, and are soft and bendy with a strong smell of sweet anise.

SUMMER

WILD FENNEL AND
WATERMELON GAZPACHO

Excellent on a long hot summer evening when you don't want the oven or the hob heating up the place. This zesty cold soup is packed with flavour and only calls for a little bit of chopping, followed by a lot of happy eating.

SERVES 6–8

½ a watermelon
1 red pepper
1 tbsp balsamic vinegar
2 tbsp extra virgin olive oil
½ a cucumber

120g wild fennel leaves,
 plus a bit extra to garnish
1 red onion
½ a red chilli

Remove skin and seeds from the watermelon and deseed the pepper, peel the cucumber and onion, then roughly chop all ingredients and place in a blender or in a bowl for hand-blending. Blend until you reach your desired consistency – although I think chunky is best with this one. Season to taste and chill in the fridge for 30 minutes before serving with a fennel garnish.

ALTERNATIVE IDEAS Having a dinner party? Add some wild fennel, rhubarb, sugar and blood orange to your guests' welcome G&T. Also tasty in tea, sauces and salads.

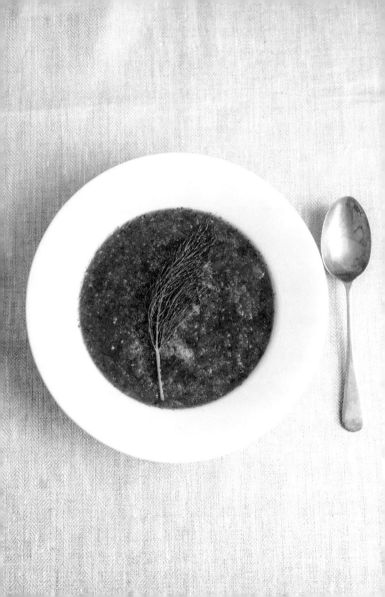

ELDERFLOWER

Sambucus nigra

AVAILABLE May–June

WHERE Roadsides, parks, waste ground, canal paths, heathland, commons

CAUTION Do not pick if covered in blackfly (this plant in particular can attract them)

Is there anything that says midsummer more than the heady smell of elderflower? This British native grows abundantly but only for a couple of months per year. With its large bouquets of tiny, pollen-dusted flowers and delightful scent, it's unmissable.

IDENTIFICATION This bright tree grows from 2–10 metres tall. The bark is greyish-brown in colour and has deep ridges – the younger branches are very brittle as they have a hollow centre. The leaves are a pointed oval shape with serrated edges and grow in parallel pairs with a single leaf at the tip. The tiny individual white flowers are star-shaped and cluster in saucer-sized blooms, and of course give off that famous smell.

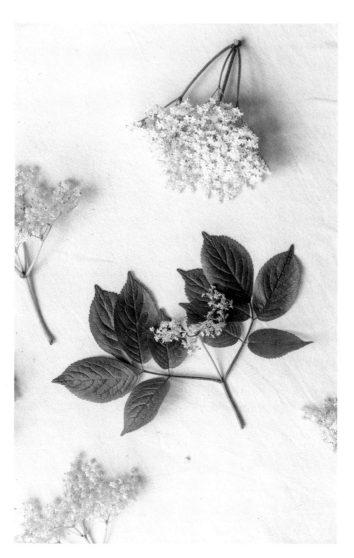

SUMMER

ELDERFLOWER FRITTERS

A hands-on dessert that's light and fluffy, hot and sweet, and fresh as summer rain. It's a quick one to put together and great for sharing, and when you've done it once it will become an annual seasonal dessert in your house, just like it has in mine.

SERVES 4

8–10 elderflower heads
100g plain flour
175ml sparkling water
1 egg white
300ml sunflower oil
100g caster sugar
300g natural yogurt
 for dipping

Rinse the elderflowers under a cold tap and hold the stem while tapping the flower head on the palm of your hand to remove any bugs or grit, then place on paper towels to dry. Mix the flour and water together until you get a thick paste, then leave to rest for 30 minutes. Beat an egg white until fluffy and slowly fold it into the rested mixture. Heat the oil in a saucepan (test it's hot enough with a drip of batter – it should cook immediately). Dip the flowers into the paste and then into the hot oil, removing once the batter is browned – 10–15 seconds or so. Serve with caster sugar and yogurt for dipping.

ALTERNATIVE IDEA Make a tasty sparkling drink by putting a mix of ¼ hot and ¾ cold water, honey, lemon and elderflower into a container and leaving it to ferment. Stir once a day for a week.

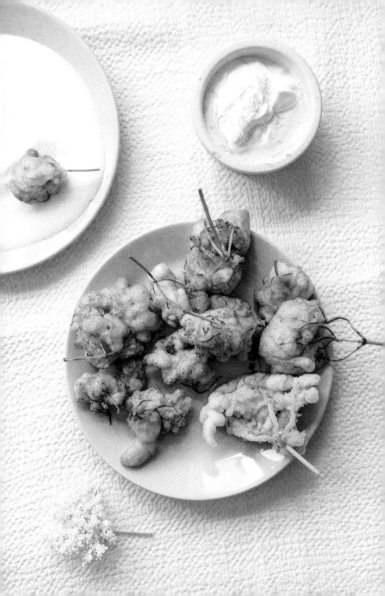

MUGWORT

Artemisia vulgaris

AVAILABLE May–September

WHERE Roadsides, parks, waste ground, marshes, embankments

CAUTION Do not consume if pregnant but otherwise totally edible. Not to be confused with poisonous wolfsbane (*see* p.185)

Mugwort is a fascinating plant with a unique and slightly bitter taste and a scent not dissimilar to sage. It's been used as a medicinal herb throughout history: stuffed into Roman soldiers' sandals on long marches, hung in the doorways of China to exorcise demons of the unwell and smoked by sailors during long voyages. Native Americans would burn it to purify their environment and place a few leaves under their pillow to encourage lucid dreaming.

IDENTIFICATION Mugwort plants grow up to 2 metres tall, often in groups. The long, thin purple stem of the main plant (not pictured) has ridges that run vertically. The pointy-edged leaves are dark green and smooth on top but have a striking silvery underside with a downy hair texture – a unique feature of mugwort. The flowers grow in clusters and the individual heads are no larger than 5mm. They look like hordes of tiny green downy eggs, with yellow to reddish-brown petals protruding from their tip. The smell is somewhere between sage and marijuana... not only unmistakable but unforgettable.

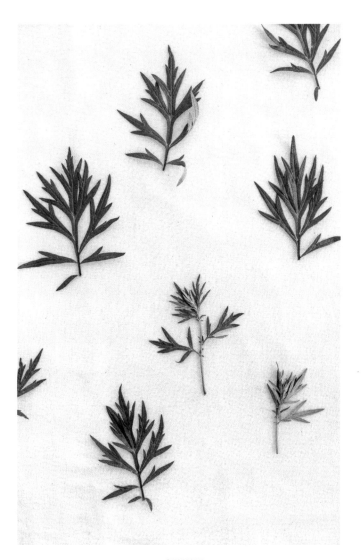

SUMMER

MUGWORT MILK BREAD

A traditional Japanese sweet-tasting bread that's fun to make. It's the fluffiest bread you will ever bake. The satisfying action of peeling apart its sections is as addictive as the taste.

MAKES 2 LOAVES

3 tbsp milk, plus 5 tbsp
375g bread flour, plus 2 tbsp
35g sugar
1 tsp salt

1 tbsp dried yeast
1 large egg, plus 1 egg yolk
35g unsalted butter, melted
75g chopped mugwort

Make a roux by whisking together 3 tbsp milk and 2 tbsp bread flour with 3 tbsp water in a smallish pan. Whisk constantly on a medium-low heat until it comes to a simmer and thickens. Allow to cool. Put all remaining ingredients in a mixing bowl and add the roux. Mix using your hands until combined and sticky. On an unfloured work surface, knead until it becomes elastic and stops sticking to your fingers. Return to the bowl and cover loosely with a tea towel. Leave to rise in a warm place for 1 1/2–2 hours. Then, divide into 8 equal pieces. Roll each segment into a 15cm circle, about 1.5cm in depth. Imagine it is a clock face and fold in the 12 and 6 o'clock edges so they touch in the centre, then roll up from 9 to 3. Take two lightly greased 22 × 8cm bread tins and place 4 dough pieces in each (NB: I used 5 and 3 pieces as I had two different sized tins), with the rolled ends touching the edges. Cover and leave for 45 minutes or until doubled in size. Add a little water to the egg yolk and brush it over the loaves. Bake in an oven preheated to 180°C for 30 minutes until golden and cooked through.

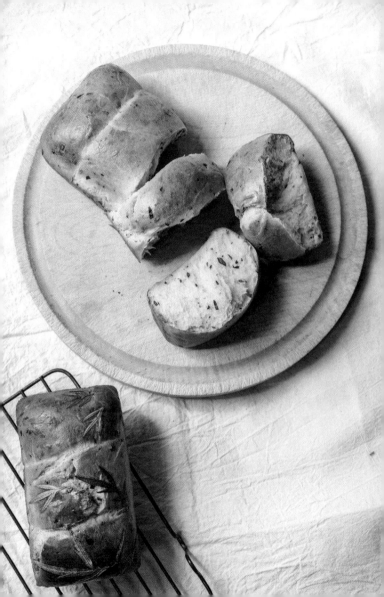

PINEAPPLE WEED

Matricaria discoidea

AVAILABLE May–October

WHERE Roadsides, waste ground, pathways

CAUTION Can be confused with chamomile and mayweed. Both are edible. There are some reports of allergy to this plant so try a small amount a day or so before consuming any more.

This little plant is amazing. Not only do the yellow flowers look a little bit like a tiny upside-down pineapple, they taste and smell strongly of pineapple too. It originated in northeast Asia and is now found in cities across the world, adding a tropical touch to urban landscapes.

IDENTIFICATION This short, stumpy plant only grows up to 20cm in height, so it can be easy to miss if you're not paying attention. Look out for hairless leaves shaped like lots of mini rocket leaves stuck together, topped by yellowy-green, dome-shaped buds – a bit like a daisy without the petals. If you're not sure, the big giveaway is the strong pineapple scent you get when you roll the flower bud between your fingers.

SUMMER

PINEAPPLE WEED GRANITA

A classic refreshing Sicilian semi-frozen dessert, and the perfect medium to showcase this plant's fantastic tropical flavour.

SERVES 2
150g pineapple weed (leaves and flowers)
100g caster sugar
300ml water

Bring the water to a boil in a medium saucepan and stir in the pineapple weed. Remove the pan from the heat and leave to cool for an hour. Add the sugar and bring to the boil again. Reduce the heat and simmer for 3 minutes, stirring frequently. Remove the pan from the heat and allow to cool. Sieve the mixture into a freezable container and freeze for 2 hours, then scrape and mash and move the ice around, before refreezing it for another 30 minutes. Repeat this process one or two more times until your desired texture is achieved.

ALTERNATIVE IDEAS Infuse melted butter with pineapple weed before adding the butter to a cookie dough. Or, use the flower heads to make a cordial or jelly.

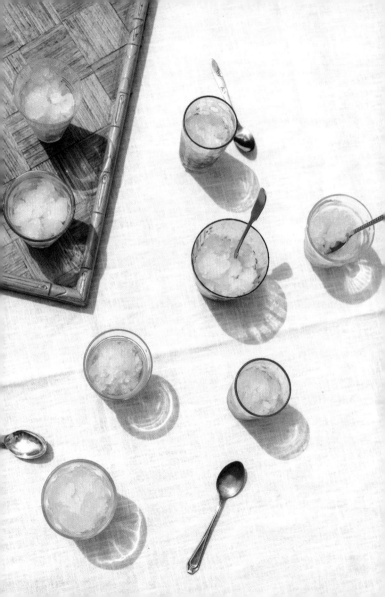

WILD FIG

Ficus carica

AVAILABLE June–Aug
WHERE Parks, gardens
CAUTION The milky sap can irritate the skin

Figs were first grown in Britain as far back as the 1500s, when Cardinal Archbishop Pole brought a fig tree back from Italy to plant at Lambeth Palace in London, which still bears fruit today. They are thought to be the sweetest of all the fruits due to their 55 per cent natural sugar content, but you can be the judge of that.

IDENTIFICATION The fig tree grows up to 6 metres tall. Its long, thin sporadic branches and glossy, hand-like leaves make it quite unusual looking. Its bark is a matt silvery-grey colour with a smooth texture. The leaves are dark green with 3 or 5 fingers and have yellow veins running through them. The pear-shaped fruit turns from green to purple as it ripens and is best and juiciest when the skin is more on the purple side. Try giving it a squeeze to judge its ripeness, just like you would at the greengrocers.

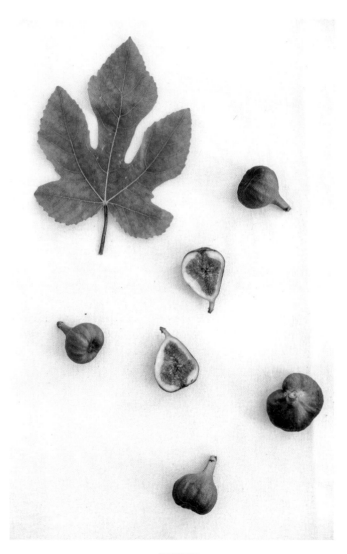

SUMMER

STUFFED WILD FIGS

Here's a flavour combination that is not to be messed with: sweet, creamy, sharp and crunchy, all in one mouthful. This dish is a rare gem in that it is as good served hot as it is cold.

SERVES 2
6 figs
50g walnuts, chopped
200g gorgonzola

Cut a cross in the top of the fig to about halfway down the body of the fruit. Pull apart the four edges and stuff with the gorgonzola before topping with chopped walnuts. To serve hot, stick it in the oven at 180°C for 10 minutes to get all the goo and melting going.

ALTERNATIVE IDEAS Preserve your figs in a spiced syrup made by boiling sugar in water with spices. You could also dry your figs out and eat as a snack or serve them as a dessert with ice cream.

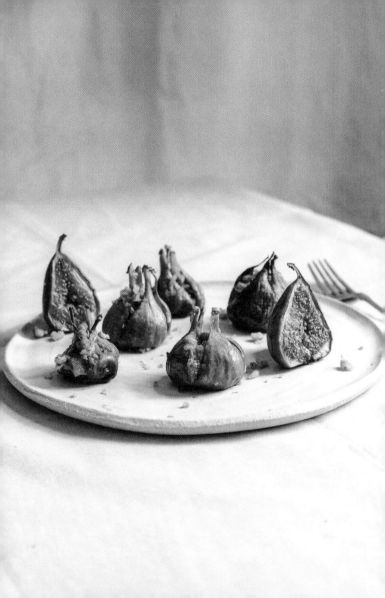

HONEYSUCKLE

Lonicera

AVAILABLE June–August
WHERE Roadsides, parks, pathways
CAUTION The berries that follow in the autumn are mildly poisonous

As its name suggests, this beautifully scented plant often found tumbling over walls and fences produces a nectar that can be sucked from the base of its flowers. So why not give it a go when you're next out foraging, or even on your way home from a night out – the flower's scent is at its strongest at night to attract pollinating moths. I'm sure you won't get any funny looks.

IDENTIFICATION A climbing vine that can cover vast distances, honeysuckle has green egg-shaped leaves with tiny stems that grow in parallel pairs and have a smooth edge. There can be up to 12 petals per flower head, with lots of fine tentacles shooting out from the centre. The flowers can be white, yellow, orange, pink or purple, with a sweet smell unlike any other.

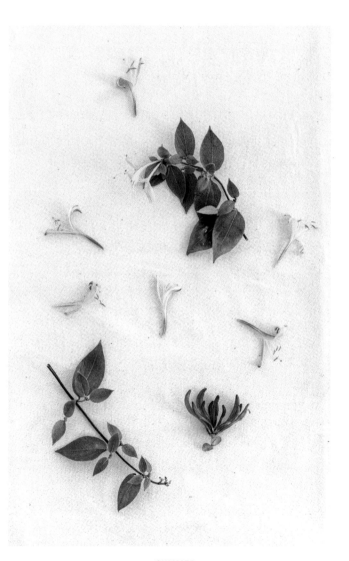

SUMMER

HONEYSUCKLE ICED TEA

A simple recipe that gives you a little something different to sip at a sunny Sunday afternoon BBQ (so long as you remember to start it off in advance.)

SERVES 2
30g honeysuckle
500ml water
½ a lemon, sliced
Ice, to serve
Extra blossoms, to serve

Boil the water and add the honeysuckle petals. Leave to steep for 2–3 hours before leaving it in the fridge overnight. Strain the liquid through a sieve or muslin cloth and serve with ice, lemon and extra blossoms.

ALTERNATIVE IDEAS Use honeysuckle as a garnish on summer salads or turn it into a syrup to drizzle over yoghurt.

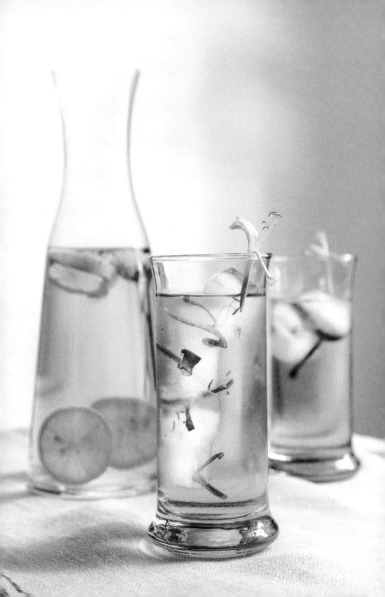

MEADOWSWEET

Filipendula ulmaria

AVAILABLE July–September
WHERE Roadsides, pathways, marshes
CAUTION Can cause stomach complaints if taken in large quantities

A favourite of mine as well as Queen Elizabeth I, meadowsweet has been popular for centuries for its beauty, its fantastic honey, almond and vanilla scent, and its medicinal and culinary qualities. Mostly used to flavour mead and ale, it has even been discovered in Bronze Age burial sites in Wales and Scotland.

IDENTIFICATION You'll spot meadowsweet wafting in the breeze, with its custard-coloured, almond-scented candyfloss tufts sitting atop a red (or sometimes green) stem that can grow up to 1.5 metres tall. The leaves – which also have a strong, sweet smell – tend to grow on the lower, younger branches, climbing up the branch with 3–5 leaves shooting out from its tip. They are a deep green on top and a paler green underneath, with a serrated edge and ridges running from its edge into the central stem.

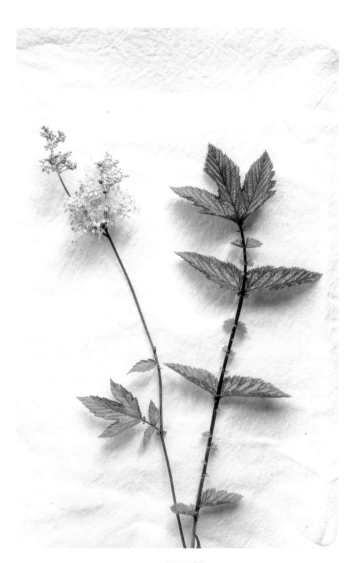

SUMMER

MEADOWSWEET PASTÉIS DE NATA

These little handfuls of crispy, crunchy, wobbly sweetness will be firm favourites in any household they grace – you'll be having them for breakfast, lunch and dinner.

MAKES 8

400ml milk
5–6 meadowsweet blooms
1 egg and 2 egg yolks
120g golden caster sugar

2 tbsp cornflour
2 tbsp cinnamon
*1 ready-rolled puff pastry
 sheet*

In a saucepan, bring the milk and meadowsweet to a simmer, remove from the heat, cover and leave to infuse for around 20 minutes. Combine the egg, egg yolks, sugar and cornflour in a mixing bowl. Strain the milk and bring it to a simmer once more. Gradually add the egg mix to the pan, continuously whisking until combined. Remove from heat and stir until thickened. Lightly butter a muffin tin and preheat the oven to 250°C. Sprinkle the cinnamon over the pastry. Cut it in half lengthways, then drag one half on top of the other. Roll into a log and cut into 8 even little logs. Put each one in a baking tin hole and press down with your thumb, spreading the pastry up the sides of the moulds. Fill the pastry ¾ full of custard and bake for 20 minutes.

ALTERNATIVE IDEAS Add boiling water to meadowsweet to make a tea or infuse some double cream with the plant before whipping the cream and filling a sponge cake.

MULBERRY

Morus nigra

AVAILABLE August–September

WHERE Roadsides, parks

CAUTION Unripe berries can contain a mildly toxic sap; juice of the fruit can stain the skin and clothes

Here's a foraging challenge for you! The fruit of this tree is only in season for a few weeks, and it's almost impossible to buy in shops, so finding a fruiting tree is a real coup. The black mulberry (pictured opposite) is found across Europe, whereas red mulberries are found in America. Excavations of Roman sites in London suggest mulberries have grown in the city as far back as the 1st century AD. King James I was also into mulberry trees, and planted lots during the 1600s to feed the silkworms he hoped to cultivate.

IDENTIFICATION Growing up to 9 metres tall, the mulberry's orangey-brown trunk is often short and fat with bumps and lumps, supporting long and winding branches that have bendy twigs at their tips. The 8–10cm leaves are heart-shaped and quite thick with a rough texture. The fruit that hangs beneath the leaves looks like a long blackberry. It starts off green, before turning a pinkish colour and then a purple/black shade when ripe and ready for picking. Do wear gloves when picking – the fruit will stain hands and clothes.

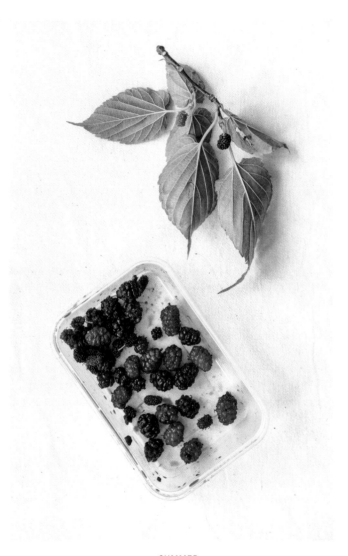

SUMMER

MULBERRY BAKEWELL TART

A proper Bakewell recipe with a wild fruit flourish that you'll find yourself pining for when mulberry season has passed.

SERVES 8

120g unsalted butter, softened, plus extra for greasing
1 ready-rolled shortcrust pastry sheet
120g golden caster sugar
3 eggs
120g ground almonds
1 tbsp plain flour
200g mulberries
25g flaked almonds, to decorate

Grease a tart tin (23cm width × 4cm depth) with a little butter before lining it with the pastry. Cover with parchment, fill with baking beans and blind bake at 180°C for 15 minutes. Remove the paper and beans and bake for 5 more minutes. Beat together the butter and sugar until light and fluffy, then whisk in the eggs one at a time before folding in the flour and ground almonds. Remove the pastry from the oven and cover the base with mushed up mulberries before adding the almond mixture and smoothing out evenly. Bake for a further 20–25 minutes or until golden brown, covering with foil 15 minutes in. Sprinkle the flaked almonds on top and serve.

ALTERNATIVE IDEAS Make a delicious jam to bring out at breakfast time. Or, to make a chutney, cook your mulberries down to a mush on a low heat with fennel seeds, sugar, lemon juice, paprika and salt.

CRAB APPLE

Malus sylvestris

AVAILABLE July–September
WHERE Parks, pathways, commons, heathland, marshes

An ancestor of the cultivated apple tree, this wild relative bears fruits that are sharper in taste but far more flavoursome when cooked. It is native to the UK and has long been associated with love and marriage. According to folklore, if you throw the crab apple's pips into a fire while saying the name of a loved one and the pips explode then the love is true.

IDENTIFICATION A bit of a loner, crab apple trees tend to grow on their own. Mature trees can reach 10 metres tall and live up to 100 years. You're looking for a single trunked tree with speckled brown-grey bark with low-growing gnarled and knotted, uneven branches. The oval leaves have soft serrated edges and progress from light green during spring to dark green when the tree is fruiting. In autumn, the leaves are orange or reddish. The crab apple tree is of course most identifiable by its small fruit of anywhere from 2.5cm to 8cm across. These vary in colour, from red to green to yellow, and have a plain or dappled complexion. Also, keep an eye out for these trees in spring, when they display their pink-and-white, sweet-smelling blossoms.

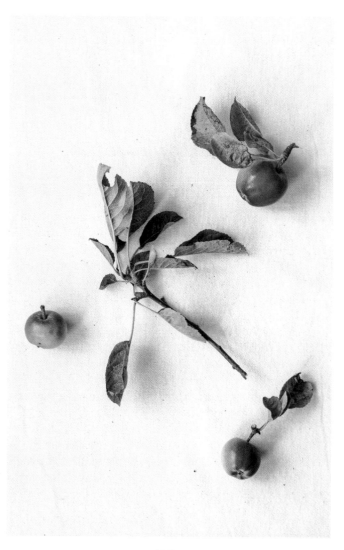

SUMMER

CRAB APPLE TARTE TATIN

A foolproof classic, celebrating a humble wild ingredient. It's as sweet and sticky as it is moreish.

SERVES 8

10–12 crab apples
100g golden caster sugar
1 ready-rolled puff pastry sheet

40g unsalted butter
200g crème fraîche

Roll out the pastry and place a heatproof pan (approximately 20cm across) on top. Cut around the pan and set the pastry aside in the fridge. Preheat the oven to 180°C. Cut the apples in half and remove the core. Pour the sugar into the pan and shuffle to even it out, then add 3 tbsp water and place on a medium heat. As the sugar begins to dissolve and caramelise, add the butter and stir until bubbling. Add the apples and stir thoroughly to coat. Reduce heat and leave to simmer for 15 minutes, until they start to soften. Remove from heat, arrange the apples cut side up and cover with the pastry, tucking it in at the sides as best you can. Make a few small holes to let the steam escape. Cook in the oven for 30–35 minutes. Leave to cool a bit before turning out of the pan. Serve with crème fraîche.

ALTERNATIVE IDEAS Plan ahead and make some autumn rum by adding chopped crab apples, honey and spices to it and storing in a jar until Bonfire Night. Crab apple is also great in desserts, smoothies and jelly.

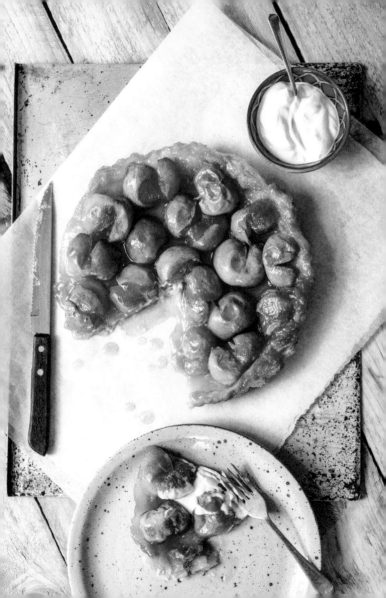

BLACKBERRY

Rubus fruticosus

AVAILABLE August–September
WHERE Roadsides, pathways, waste ground, heathland, commons, marshes
CAUTION Fruit grows amongst sharp thorns and/or brambles

The best-known and most commonly foraged fruit by far, this is where many aspiring foragers start out – coming home with purple fingers and scratched arms. As a kid, it seemed amazing to me that these tasty jewel-like treats popped up everywhere and could be gathered for free. And actually, it still does now. Considering their extremely high nutritional value, fantastic taste and that you hardly need look further than the nearest bit of uncultivated ground, why wouldn't you go blackberry picking?

IDENTIFICATION These dense scrambling shrubs can grow up to 3.5 metres tall. The stems can be a mix of green, purple or reddish brown, with lots of small sharp thorns pointing out from all directions. The branches or canes shoot out almost at right angles and the dark green, oval-shaped pointy leaves have serrated edges and thorns growing along the spine of the underside. The fruit is a berry made up of lots of tiny drupes, resembling caviar, all clustered together, starting off white, before turning red and then ripening into a deep shade of purple/black.

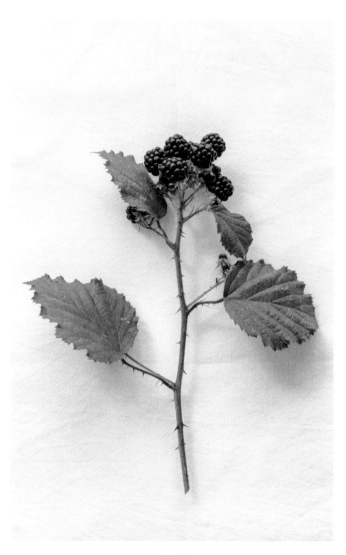

SUMMER

BLACKBERRY, BRIE AND BASIL TOASTIE

This toastie laughs in the face of its peers. Sharp, sweet, salty and aromatic with a crisp and gnarly crust and a fruity, gooey centre, it's ready to eat in minutes.

SERVES 1

2 thick slices of
 wholemeal bread
20g salted butter
75g blackberries

Small handful
 of basil leaves
75g brie
40g parmesan

Spread half the butter on the two slices of bread, then mash the blackberries and spread across one slice, leaving the juice behind. Slice the brie and layer it on top of the blackberry. Top that with whole basil leaves and season before sandwiching with the other slice, buttered side down. Melt half the remaining butter in a non-stick frying pan over a medium heat. Cook the sandwich for three minutes on one side, then lift out and butter the top of the slice that's facing you before flipping and cooking for 3 more minutes. Remove the sandwich from the pan, grate half the parmesan directly into the pan and pop the sandwich back in for 2–3 minutes to crisp up. Repeat with the remaining parmesan for the other side of the sandwich, then slice and enjoy.

ALTERNATIVE IDEAS Another berry that's perfect for jam or chutney. For a pudding, make some brownies and add wild blackberries and a little rosemary into the mix.

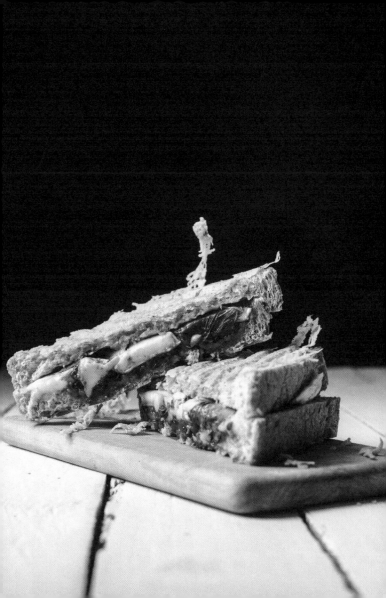

AUTUMN

As the leaves put on their annual
display of gold and red, an array
of berries and nuts start to appear on
trees and hedgerows. Turn these
into sweet preserves and sloe gin and
enjoy throughout the seasons.

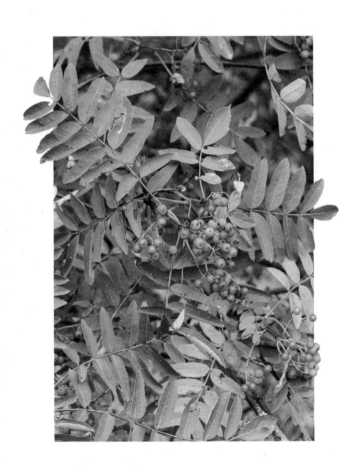

Rowan berry, p.128

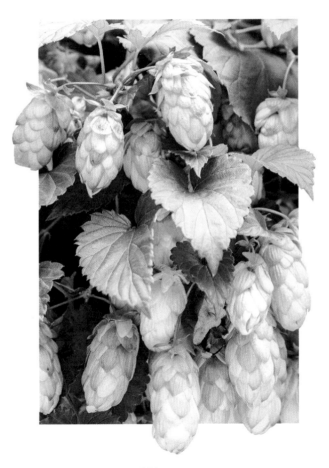

Wild hops, p.132

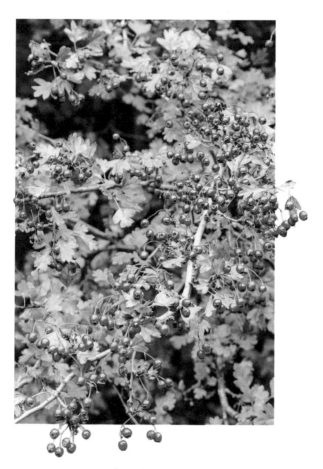

Hawthorn berry, p.136

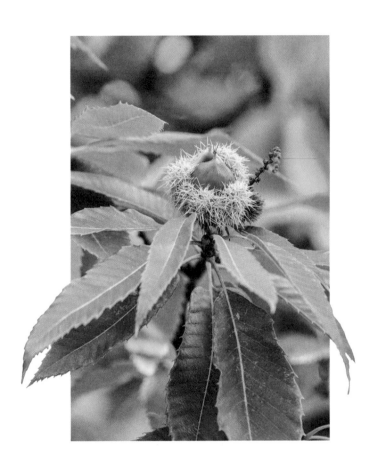

Sweet chestnut, p.140

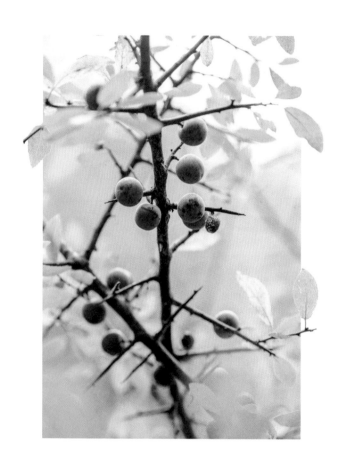

Sloe berry, p.144

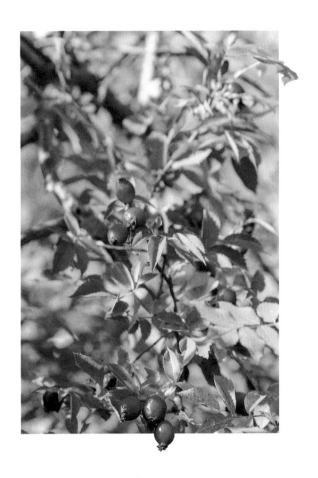

Rosehip, p.148

ROWAN BERRY

Sorbus aucuparia

AVAILABLE September–November
WHERE Roadsides, pathways, parks, heathland, commons
CAUTION Only edible when cooked. Poisonous if eaten raw in large quantities.

These cheery bright red or orange berries are packed with vitamin C and antioxidants, and taste a bit like cranberries when cooked. Rowan trees are ridiculously easy to find so this is a great place to start if you're a novice forager. This tree was believed to ward off evil spirits. Its old Celtic name is *fid na ndruad*, which means 'wizard's tree'. So – delicious *and* magic.

IDENTIFICATION Rowan trees grow all over the city in parks, on pavements and in gardens. It's a small tree with smooth, yellowy-brown bark and no thorns. The leaves are usually 3–6cm long and grow in 5–8 parallel pairs. They have a pointed tip and a fine jagged edge. The red or orange berries are firm and pea-sized. They hang in clusters, sporting a distinctive black star-shaped indent at their base.

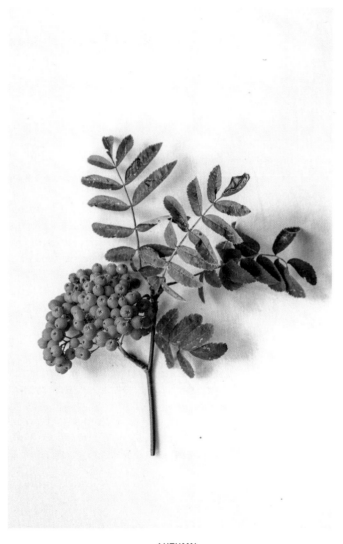

AUTUMN

ROWAN BERRY JAM

This delicious jam has a distinctive sweet and tangy taste – ideal for slathering on cheese and crackers.

MAKES APPROX. 500g
1.5kg rowan berries
750g cooking apples
1.25kg sugar

Wash both fruits and quarter and core the apples. Place in a large cooking pot and cover with 1.5 litres of water, then bring to the boil before reducing to a simmer for 20 minutes until soft and mushy. Pour the whole pulpy mess into muslin cloth-lined sieve over a large pan. Leave it to rest overnight without touching it so all the liquid drains into the pan below. Discard what's left in the sieve (or you could use these remnants in a smoothie or on your breakfast granola). Over a medium heat, add the sugar to the pan containing the juice, stirring occasionally until it dissolves. Then increase the heat to high and boil for 40 minutes, until thickened. Once cool, pour into sterilised jars, seal and keep in the fridge for up to two weeks.

ALTERNATIVE IDEA Add nutmeg, cinnamon or other spices to the jam at the same time as the sugar for a spiced variation. Both the regular and spiced versions make scrumptious toppings for granola and yogurt.

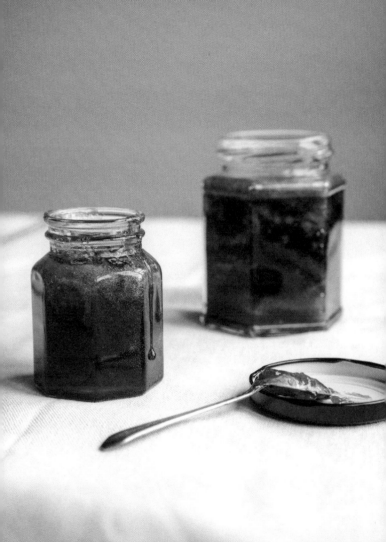

WILD HOP

Humulus lupulus

AVAILABLE September–November
WHERE Parks, waste ground, roadsides

Many people don't know that hops grow wild, and they can be hard to spot, but find some and you'll be basking in a sense of achievement – as well as its rather heady, marijuana-like smell! The wild hop loves to climb along fences, gates and railings all over the city, wrapping its light green shoots around anything it can find, and producing beautiful green papery flowers.

IDENTIFICATION The distinctive, beehive-shaped flowers are light lime green in colour and soft and papery to the touch. They are 2–8cm in length, with overlapping tongue-shaped petals that point toward the tip.

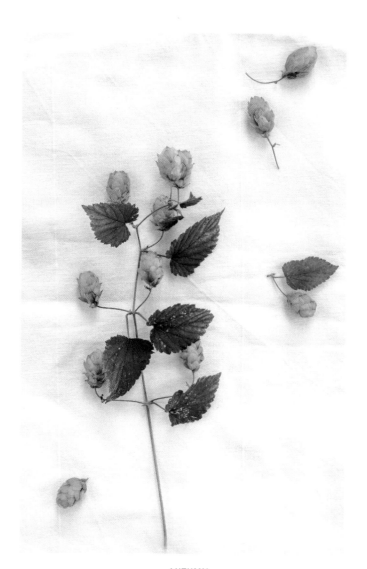

AUTUMN

WILD HOP BEER

To tell the truth, I have no idea when it comes to brewing beer from scratch. To make a beer completely out of wild hops you'd need to dry a whopping 5kg of them in a dehydrator, along with plenty of grain. So I went for the easy option and bought a home brewing kit off the internet. It was a pretty straightforward process and very enjoyable. Almost as enjoyable as the end product! Make sure you have a thermometer and some bottles or containers to store your delicious beer in before you start.

MAKES APPROX. 40 PINTS
1kg wild hops
Home brewing beer kit

I followed the instructions that came with the kit, adding my wild hops five minutes before the end of the boil for a final kick of flavour. The making process takes only a few hours then you'll need to wait two weeks for the beer to brew before bottling. The hops remain in the brew for the fortnight, allowing for a deliciously rich, hoppy taste to come through. My beer tasted fantastic. I highly recommend trying a kit: at around 40p a pint you could throw an open bar party and come across as the most generous host to your guests. Little would they know!

ALTERNATIVE IDEAS Infuse some malt vinegar with wild hops – they provide a pleasant, beery tang (perfect for chips). In spring, the shoots of this plant can be steamed like asparagus.

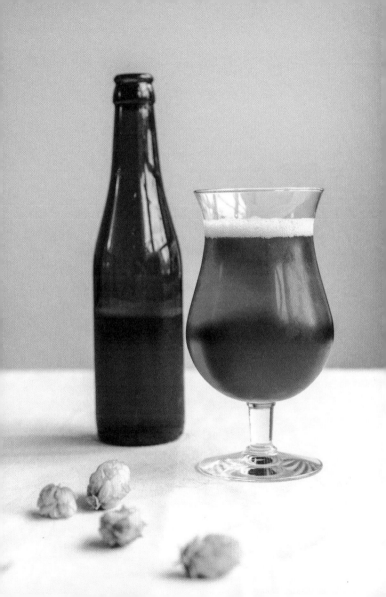

HAWTHORN BERRY

Crataegus monogyna

AVAILABLE September–November
WHERE Pathways, heathland, commons, marshes
CAUTION There's a large pip inside the berry (which you shouldn't eat) so watch your teeth

With their appley taste and crimson hue, haws are the very epitome of autumn – so get out there and grab some of these tasty treats. If you pinch the top of the berry where it attaches to the stem it'll pop off into your collection vessel. As well as being a fun game (you can get them to pop surprisingly big distances), this saves time back at home, as all hawthorn berry recipes begin with the dreaded words: 'Remove the stalks from the berries'.

IDENTIFICATION Hawthorn berries can grow on both shrubs and trees, the latter of which can grow up to 12 metres tall. The plant has short spiky branches that are often tangled. Growing in two or three tiers, the leaves have a rough texture underneath and a smoother one on top. A long, thin stem attaches the leaves to the branches. The berries are about the size of a pea and have a black circle at their base, which is hugged by tiny leaves that form a starfish shape.

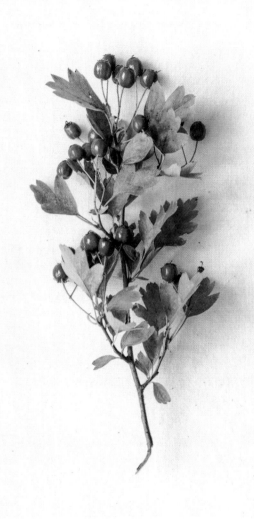

AUTUMN

HAWTHORN BERRY KETCHUP

This zingy condiment has a sweet 'n' sour sauce vibe with a soft tang. It's easy to make and well worth a go, not least because it goes brilliantly with chips, Chinese food and pizza. Try stirring it into baked beans too – you won't do it just once.

MAKES APPROX. 400g
500g hawthorn berries
300ml cider vinegar
175g sugar

Remove the stalks from the berries and wash thoroughly. Add to a large pan with 300ml water and the cider vinegar. Bring to a boil and simmer very gently for half an hour or until the skins soften and start to break. Don't worry – that piercing vinegar aroma will quickly turn into a sweet, sugary smell! Strain the berries through a sieve (the inedible pips will gather in here), collecting the liquid in a clean pan. Add the sugar and gently heat whilst stirring until dissolved and the bottom of the pan feels smooth. Bring to a boil, then reduce the heat and simmer gently for 15–20 minutes. Remove from the heat, season to taste and leave to thicken and cool. Serve right away or spoon the ketchup into a sterilised jar or bottle to save for later.

ALTERNATIVE IDEAS Make a hawthorn berry jam using the rowan berry recipe (*see* p.130) or dry out the berries and use in a tea.

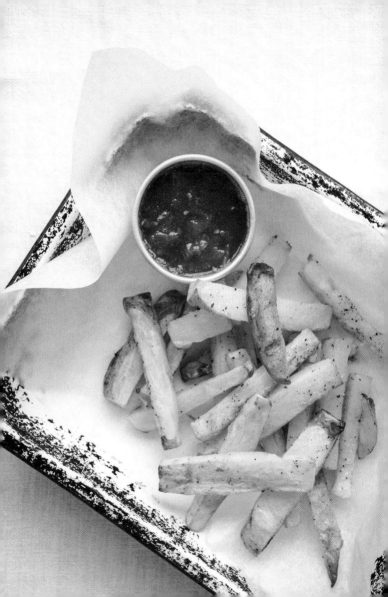

SWEET CHESTNUT
Castanea sativa

AVAILABLE October–November
WHERE Parks, commons, woodland
CAUTION Not to be confused with the poisonous horse chestnut
(*see* p.186)

It's easy to spot sweet chestnut's bright green, unbelievably spiky husks lying under the tree in autumn. For obvious reasons, it's best to choose the ones that have already started to open – you may even be able to see the glossy chestnuts inside. These nuts have a rich, earthy taste and, while cooking, give off the most amazing toasted smell.

IDENTIFICATION The tree's deep green leaves are long and slender with toothed edges and a bold yellow stem running right through the centre. The snooker ball-sized husks are bright green and very spiky. They generally grow in clusters. When they're ready the husk splits so you will see 2 or 3 deep brown nuts inside. Each nut has a flat side and a point that has hairs protruding from it (a tail, of sorts).

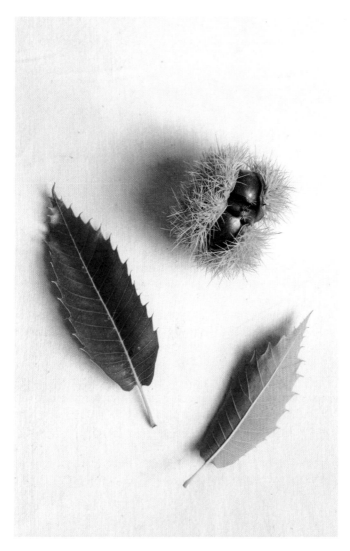

AUTUMN

SWEET CHESTNUT CHEESE

This plant-based cheese is a strong-tasting, crumbly delight with citric and salty notes. It's a joy to make too.

MAKES 250g

300g sweet chestnuts (15–20 husks), with husks removed
2 cloves garlic
Juice of 1/2 a lemon

2 tbsp nutritional yeast
1/2 tsp salt
1 tbsp miso paste
50g kelp powder

Cut the tail from the brown shell, prise it open and leave the nut to soak overnight. Drain the chestnuts, removing the shells and peeling off the skin. Put the nuts, chopped garlic, lemon juice, salt and nutritional yeast into a food processor and blend together, adding water a splash at a time until it's a smooth, creamy texture that holds shape. Taste and season, then add the miso paste and combine. Shape the contents into a ball and place in the centre of a muslin cloth. Bring together all four corners of the cloth and tie tight. Place on a plate in the fridge with a weight on top of the cheese to flatten and firm. The cheese will be set in 12 hours – though 24 hours would be ideal. Remove from the cloth and roll in kelp powder, which adds a seasoned finish to the strong and sharp cheesy flavour.

ALTERNATIVE IDEAS Go all Nat King Cole and roast them on an open fire. Also great in stuffing or a Wellington.

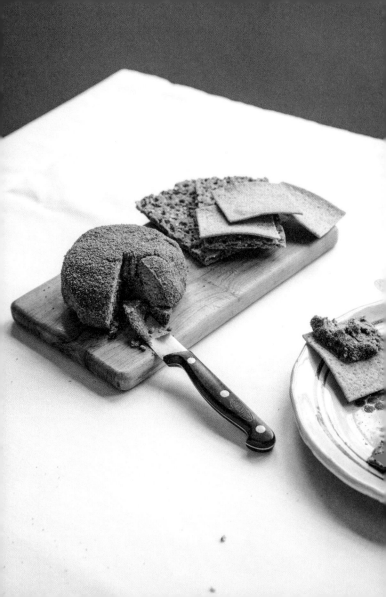

SLOE BERRY

Prunus spinosa

AVAILABLE October–November
WHERE Pathways, heathland, commons, marshes
CAUTION Wear gloves when picking your sloes to avoid getting pricked by the thorns

Finding these beautiful blue-black fruits of the blackthorn bush is a real treat. Sloes lend themselves to lots of different recipes, but the most famous is traditional sloe gin (*see* p.146). Forage carefully though – being punctured by the thorns on the branches is an experience that makes you pause for a second as you feel the shock in the depths of your soul. However, they're very visible, and though they grow pretty far back on the branches, you can just pick from the front of the bush. Clasp the berry and twist, like you would a naughty Dickensian child's ear.

IDENTIFICATION Growing up to 4 metres in height, the blackthorn tree is usually as wide as it is tall. Its branches have very dark (almost black) bark and its green oval-shaped leaves have serrated edges. The blue-black berries have green flesh inside as well as a pip.

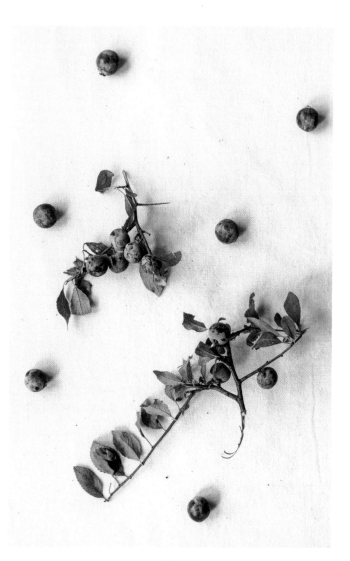

AUTUMN

SLOE GIN

This is a cockle-warmer of a recipe and makes an excellent traditional Christmas present.

MAKES 1 LITRE
500g sloe berries
250g golden caster sugar
1 litre gin

Wash the berries and put them into a 1 litre airtight jar. Add the sugar then the gin and fasten the lid. Shake well twice a week for three months. This gives the alcohol enough time to extract an almond flavour from the berries' stones, giving it a more complex flavour. Strain through a muslin cloth, squeezing all the juice from the berries by twisting the cloth tighter and tighter. Pour the liquid back through the sieve and into the jar (or hang onto the bottle the gin originally came in and use that).

ALTERNATIVE IDEAS Hunt down some unripe berries (pale green in colour) and pickle them in vinegar to serve as a substitute to olives. Sloe berry jam is another favourite of mine.

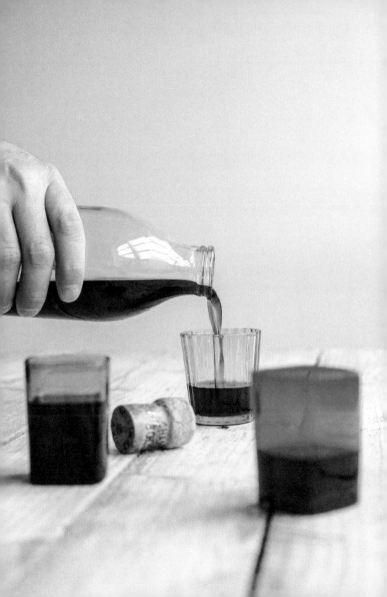

ROSEHIP

Rosa canina

AVAILABLE September–November

WHERE Pathways, heathland, commons, marshes, parks, roadsides, waste ground

CAUTION Beware of thorns and the fluffy seeds – the latter can cause irritation to the throat

You'll notice the shrub known as 'dog rose' in summer because of its pretty pink, five-petalled flowers. By early autumn these flowers have turned into small red hips, about the size of a cranberry. Rosehips have lots of uses and taste similar to crab apples (*see* p.112) – they're in the same family. I often eat them straight off the bush but if you try this be sure to break open the hip and remove all the white fluffy seeds inside first as these can irritate the throat.

IDENTIFICATION Wild rose shrubs grow up to 3 metres tall, with long, thin stems that form arches as they grow. The green leaves grow in two or three symmetrical rugby ball-shaped pairs with a single leaf at the tip of the stem. There are a couple of types of hips you can pick: one is a miniature egg shape (pictured opposite), while the other is much fatter and rounder in shape with four leaves at the tip. Both are equally delicious.

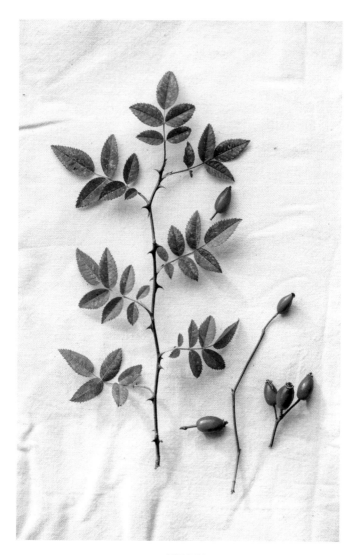

AUTUMN

ROSEHIP ICE CREAM

This tart yet ridiculously creamy dessert always goes down a storm and never hangs around the freezer for long. It's lovely on its own or with autumnal treats like blackberries or apple pie.

MAKES 1 LITRE
500g rosehips
325g of sugar for every 500ml of liquid
600g double cream
1 can of condensed milk (approx. 397g)

Wash the rosehips and chop roughly, add to a litre of water and bring to the boil, then simmer for 30 minutes. Remove from the heat and strain through a muslin cloth, wringing out all the juice from the fruit. Measure how much liquid you have in a measuring jug and weigh out the sugar accordingly. Pour the liquid into a fresh pan through a clean muslin cloth and add the sugar. Stir slowly on a low heat until the sugar has dissolved, then boil for 10–15 minutes until syrupy and thick. While the syrup cools, whisk the condensed milk and double cream in a mixing bowl until it can hold a firm peak. Fold in the cooled syrup and decant into a container suitable for freezing. Cover with cling film and freeze for 5–6 hours to set.

ALTERNATIVE IDEAS Save some of the syrup to use as the base for a delicious cocktail or a jelly.

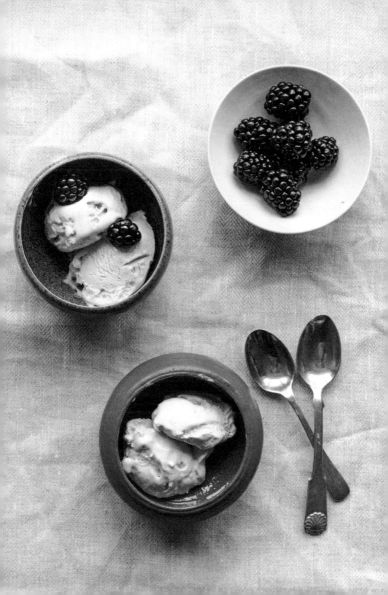

WINTER

Cold months can be hard going in
the city but there's much to be gained
from a brisk foraging walk. Get
outside and hunt for hairy bittercress,
yarrow, gorse and more.

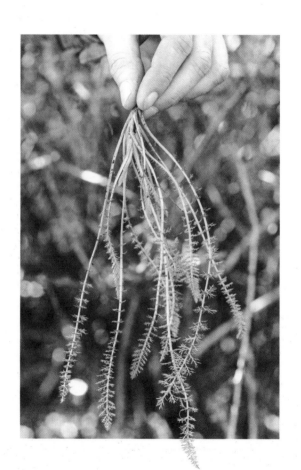

Yarrow, p.160

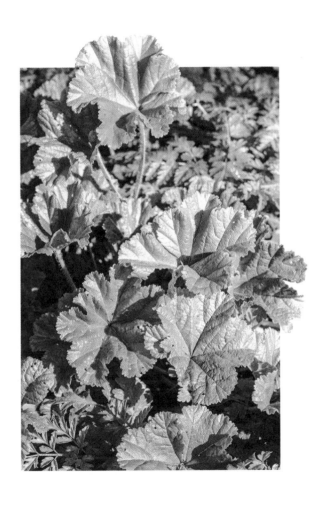

Mallow, p.164

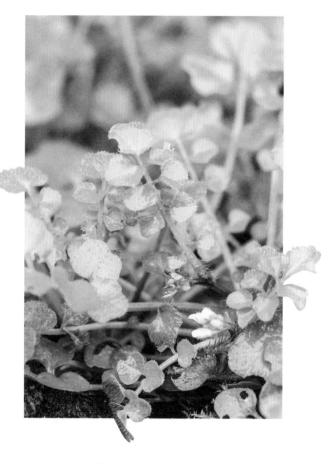

Hairy bittercress, p.168

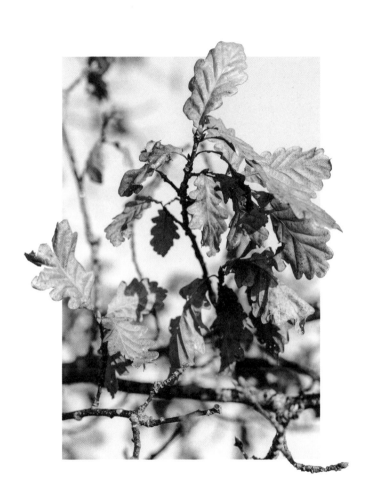

Oak, p.172

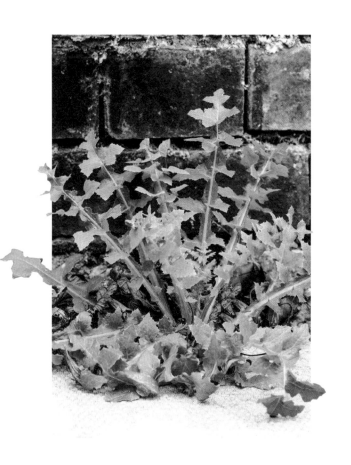

Dandelion, p.176

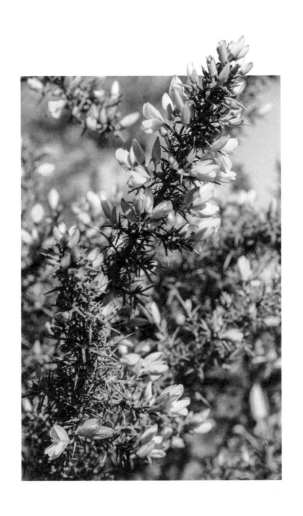

Gorse, p.180

YARROW

Achillea millefolium

AVAILABLE February–November
WHERE Pathways, parks, woodland, embankments, marshes
CAUTION Do not eat when pregnant

Yarrow has a distinctive and fairly bitter taste, but used in the right way it gives a delicious and unusual flavour to a whole host of dishes. Plus, it's easy to find. Its Latin name, *Achillea*, comes from the Greek hero Achilles, and it's said to have been used on the battlefields of Troy to stem the bleeding of the wounded warriors. If you're not a wounded warrior, it's good for digestion too.

IDENTIFICATION A distinguishing feature of yarrow is its feather-like fronds, which grow 5–20cm long and stand out from surrounding grass due to their unusual shape. Upon closer inspection, these fronds are quite soft and made up of tiny leaflets growing in a spiral around the central stem. The stem and leaves are sometimes covered in small white hairs but not always. Give this plant a rub between your fingers and it will release a spicy, herbal scent. During the summer months, yarrow bears large white flower heads.

WINTER

ONE-POT YARROW CAKE

An extremely quick and simple throw-everything-into-one-pot cake that makes yarrow sing and is as soft and crumbly as it is moist. This humble dessert is best served alone or with a spoonful of fresh yogurt and berries.

SERVES 8–12

250g yogurt
100g olive oil
120g honey
70g yarrow, plus a bit extra
 for decoration
1/2 a lemon

3 eggs
200g flour
1/2 tsp baking powder
1/2 tsp baking soda
1/4 tsp salt

Preheat the oven to 160°C. Rub butter all over a 20cm baking tin and cover the base in parchment paper. Mix the yogurt, olive oil, honey, yarrow and zest from 1/2 a lemon in a large bowl. Add the eggs one at a time, mixing in thoroughly before adding the next. Add the flour, baking powder, baking soda and salt and combine until it all comes together, being careful not to overmix – you want it a little lumpy. Empty the contents of the mixing bowl into the baking tin and put a few fresh yarrow leaves on top for decoration. Place into the centre of the oven and bake for 50 minutes, or until a knife plunged into the centre comes out clean.

ALTERNATIVE IDEAS Infuse a bottle of olive oil with some sprigs of yarrow or use some of the leaves in a wintery salad.

MALLOW

Malva sylvestris

AVAILABLE February–October

WHERE Marshes, roadsides, pathways, waste ground

CAUTION Leaves can be confused with geranium, though geranium has a much stronger smell and its flowers also differ greatly. Both are edible.

Mallow has a mild taste that works to its advantage in many dishes: it takes on the flavour of other ingredients brilliantly while it's exceptionally high in vitamins as well as calcium, magnesium and potassium. The leaves work as a thickening agent in stews and can be steeped in water overnight to produce a liquid that acts as an egg substitute in vegan baking. The ancient Egyptians were the first to use the sap from the root of the mallow plant to make sweets, mixing it with nuts and honey. However, it was a French confectioner who came up with the idea to add the sap from wild mallow gathered on salty marshes to egg whites and sugar, thus creating the original campfire treat: the mighty marshmallow.

IDENTIFICATION Growing up to 1 metre in height and up to twice as wide, this plant is hard to miss. Its crinkly leaves have jagged edges, 5–7 lobes and a split down the centre. When picking, you'll notice a gooey liquid is released from the stem, hence why this plant is used to thicken sauces.

WINTER

MALLOW KHOBEIZEH

In Palestine, it is a childhood ritual for a grandmother to take her grandchildren foraging for mallow and teach them how to cook khobeizeh, just as my nan did blackberry crumble with me. This recipe produces a simple meze dish that tastes deliciously earthy.

SERVES 2

500g mallow leaves
2 tbsp olive oil
1 onion, sliced

1 clove garlic, sliced
1/2 lemon

Soak the roughly chopped mallow leaves for a few minutes before rinsing. Add oil to a pan over a medium heat and cook the onions and garlic until golden and beginning to brown. Add the mallow and salt. Cover with a lid and leave for 10 minutes on a low heat. Remove the lid and squeeze in the juice from 1/2 a lemon. Stir for a couple of minutes and season to taste. Serve with flatbreads, olives and yogurt.

ALTERNATIVE IDEAS Stuff mallow leaves in the same way you would vine leaves, with rice, for a wild take on a classic dish. Or draw on mallow's thickening properties by bulking up a stew or broth.

HAIRY BITTERCRESS

Cardamine hirsuta

AVAILABLE All year round
WHERE Roadsides, parks, embankments, pathways
CAUTION Wash thoroughly as minuscule bits of grit and dirt seem to cling miraculously to this plant

A fresh-tasting and peppery member of the mustard family, this hardy little plant that gardeners call a pest will rapidly become a firm favourite to keep an eye out for on your morning walk. As soon as you start looking out for it, you'll notice it seems to grow absolutely anywhere.

IDENTIFICATION If you happen to see a little green rosette on the floor, chances are it's this little guy. The leaves are shaped like tiny cartoon trees, and grow in equal size and number either side of the stem with one at the head. This plant has a fibrous root system: when you're picking, clasp hold of the centre of the rosette and gently lift whilst rocking the plant back and forth. It should begin to free up. You might want to use scissors or a knife to cut underneath the plant at its centre (don't worry you won't uproot the whole plant – the roots reach 1–2 feet down into the earth). In the spring and summer hairy bittercress sports tiny white 4-petalled flowers atop a thin, 15–20cm tall stem.

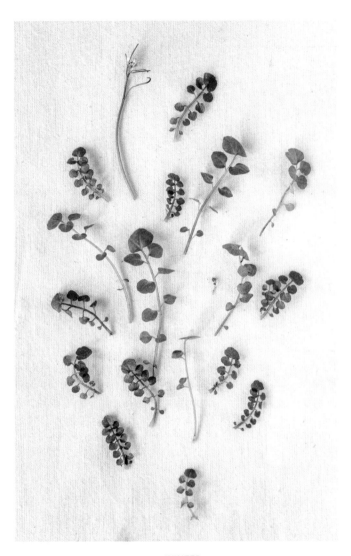

WINTER

HAIRY BITTERCRESS BROTH

This amazing plant is the star here, giving this broth an extra depth of flavour and colour.

SERVES 2

1 pak choi
2 courgettes
2 carrots
2 tbsp dark soy sauce
6 tbsp sunflower oil
Juice of 1/2 lemon
1 tbsp honey

1 thumb-sized piece ginger, chopped
1 garlic clove
1 red chilli
100g hairy bittercress
750ml vegetable stock

Scatter the ginger, garlic and chilli over a baking tray, add the oil, soy sauce, lemon juice, honey and mix well. Cut the pak choi in half lengthways and rub into the oil mixture; remove and place to one side. Slice the carrots and courgettes and add to the tray, coating well in the mixture. Lay the pak choi on top, flat side up, and roast at 180°C for 35 minutes, or until the pak choi starts to brown and crisp up. Using tongs, place the cooked carrots and courgettes into a sieve over a bowl of vegetable stock and press lightly with a spoon so that the excess liquid pours in. Chop the bittercress and add to the bowl. There will be some juices in the baking tray that can go in too. Add the courgette, carrots and pak choi to the broth and serve.

ALTERNATIVE IDEAS Try bittercress in a risotto, a pesto or add it to some roasted vegetables (it goes well with squash and beetroot).

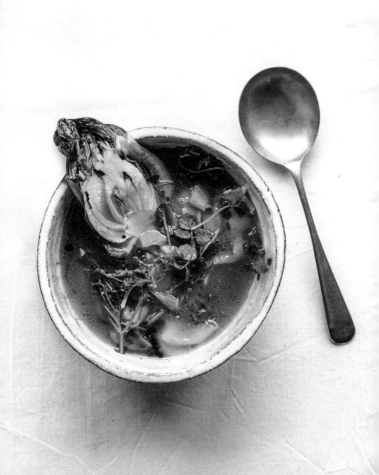

OAK

Quercus

AVAILABLE All year round
WHERE Parks, heathland, commons
CAUTION When picking, use a knife or some secateurs to leave a clean cut as tears in the bark can leave the tree susceptible to infection

If you drink wine or whisky you already know what oak tastes like – the barrels that the alcohol is stored in are traditionally made of oak. Over time, the tannins in the wood help to flavour the wine. The mighty oak tree is the most famous native tree species in the UK, and has long been regarded as a symbol of Englishness.

IDENTIFICATION The oak is often the largest natural object in any landscape. Its silver-brown trunk has deep, hefty vertical ridges that you can fit your fingers in. During winter, the tree's leaves are brown; each leaf has 4–6 lobes per side with rounded edges. Knobbly buds run along the twigs to the tip. You can look for last season's acorns underneath the tree, but the new ones won't begin to grow until autumn.

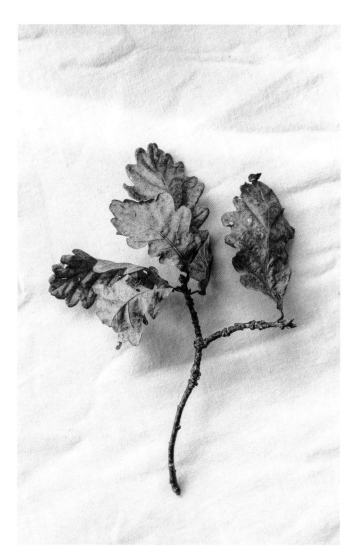

WINTER

OAK SCHNAPPS

The fascinating thing about this schnapps is that it will taste different depending on when the branches are harvested. In winter, when the tree is dormant, the wood is richer in tannins and the schnapps will have a deeper flavour. There are many different species of oak – you can use any for this recipe. Note that you'll need to wait 3 ½ months before drinking!

MAKES 1 LITRE

2 handfuls of short sticks cut from an oak tree, around 10–20cm each

1 litre vodka

4 lapsang souchong tea bags

4 tsp honey

Fill a lidded vessel with the rinsed oak branches (bark left on), pour in the vodka and screw on the lid. Leave to steep for 3 months, then add the tea bags and 4 teaspoons of honey. Leave to steep for a further 2 weeks. By then it will be an amazing deep red colour. Pour the schnapps through a muslin cloth into your glasses.

ALTERNATIVE IDEAS Acorns, which grow on oak trees, are edible and high in protein and carbohydrate. You'll need to separate the nut inside from the outer shell and soak them in water to get rid of the bitterness before grinding them up into flour-like consistency. You can use this flour to make acorn bread, or add it to a stew or porridge.

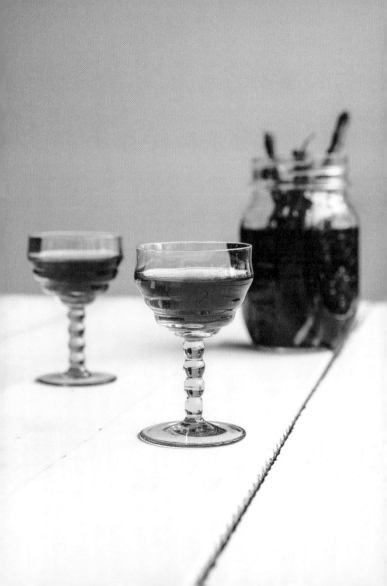

DANDELION

Taraxacum

AVAILABLE All year round
WHERE Parks, waste ground, roadsides, commons, pathways, cemeteries
CAUTION Leaves can be confused with wild radish and cat's-ear, though both are edible. Use multiple sources for an extra ID check.

Poor old dandelion is generally written off as a common weed these days, but it's been used in medicine for hundreds of years for treating kidney problems, joint pain, blood pressure and skin conditions. Its flavour is somewhere between rocket and spinach, and both the leaves and flowers can be used in lots of different dishes – so it's definitely one to experiment with. Dandelion is also an important plant for bees as it flowers early on in the spring when there's nothing else around.

IDENTIFICATION Its name comes from the French *dent de lion*, or 'lion's tooth', due its distinctive tooth-edged leaves than can grow anywhere from 5–40cm. The bright yellow flowers are the most obvious clue to identify the plant. I try to pick the leaves growing in the shade as they tend to be a bit sweeter.

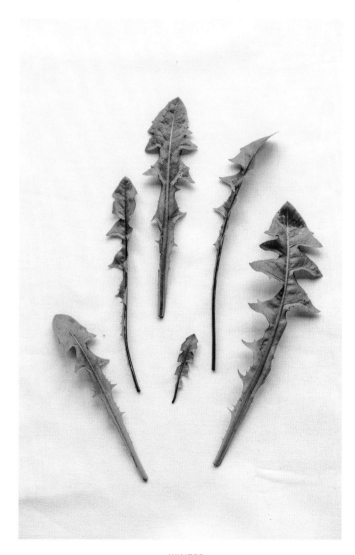

WINTER

DANDELION SAAG ALOO

Dandelion has an unfair reputation for being bland but this Indian dish will certainly prove that wrong. I've given it a medium heat but feel free to add more chillis if you like it spicy.

SERVES 4 AS A SIDE DISH

250g dandelion leaves
2 tbsp sunflower oil
1 onion
2 garlic cloves
1 tbsp ginger

1 red chilli
1/2 tsp mustard seeds
1/2 tsp cumin seeds
1 tsp turmeric
500g potatoes

Wash the dandelion leaves thoroughly and set aside. Heat the oil in a pan and add chopped ginger, onion and garlic and fry lightly for a few minutes. Cut the potatoes into 3cm cubes and add to the pan with the chilli and spices. Stir, making sure to coat the potatoes and onions well. After a few minutes, add a glug of water and place the lid on the pan to steam. Leave to simmer away gently for 10 minutes or until the potatoes are cooked. Add the dandelion leaves, stir until wilted and serve.

ALTERNATIVE IDEAS Brew a dandelion tea or try using the young leaves in any recipe where you'd usually use spinach – salads and soups work well.

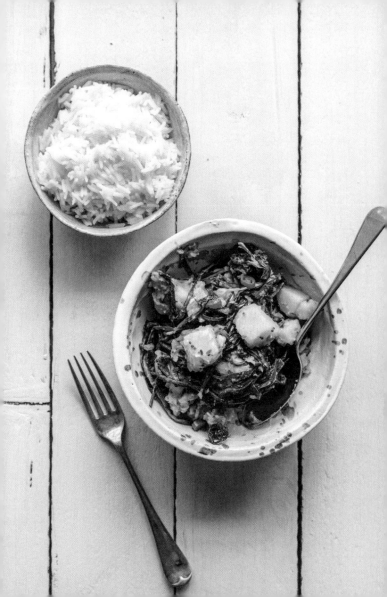

GORSE
Ulex europaeus

AVAILABLE All year round
WHERE Heathland, commons, pathways, waste ground
CAUTION Gorse bush is extremely spiky so take care – use gloves
if possible

There is a very un-catchy nineteenth century expression that I can't
imagine was used more than 3 times. It goes: 'When gorse is out
of bloom, kissing is out of fashion', which basically means gorse
is always in flower. During winter, when almost nothing is in bloom,
gorse's cheery bright yellow flowers are a cinch to identify, and
its unexpected coconut flavour means it's a great ingredient to
gather in the depths of these cold months.

IDENTIFICATION This large evergreen shrub is completely covered
in green needle-like leaves that point in all directions. This dense
bush can grow up to 2.5 metres tall, with vibrant yellow flowers
dotting about its tips, though some flowers may be more covered
than others. These yellow blooms give off a coconut scent when
rubbed between your fingers.

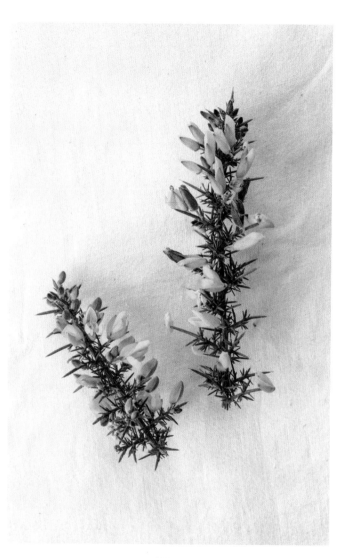

WINTER

GORSE FLOWER
PANNA COTTA

Panna cotta may seem like something fancy you'd order in a restaurant, but it's actually quite straightforward to make. So why not impress your friends by whipping up this classic Italian milk pudding with a wild, foraged twist?

SERVES 4

250ml milk
250ml double cream
300g gorse flower petals
25g granulated sugar

1 tbsp poppy seeds
3g Vege-Gel
 (or similar setting agent)

Leave the petals to soak in the cream in the fridge overnight. The next day, add the milk, sugar and poppy seeds and bring to the boil in a saucepan. Remove from the heat and add the Vege-Gel, stirring until dissolved. Strain the liquid through a sieve and leave to cool. Pour into four ramekins and set in the fridge for 2–3 hours. When ready to serve, sit the ramekins in hot water for a minute before turning the puddings out onto a plate. If you have any rosehip syrup left from autumn (*see* p.150), that would be the perfect pairing, like I've done here.

ALTERNATIVE IDEAS Gorse flowers make a cheery garnish on salads and cakes.

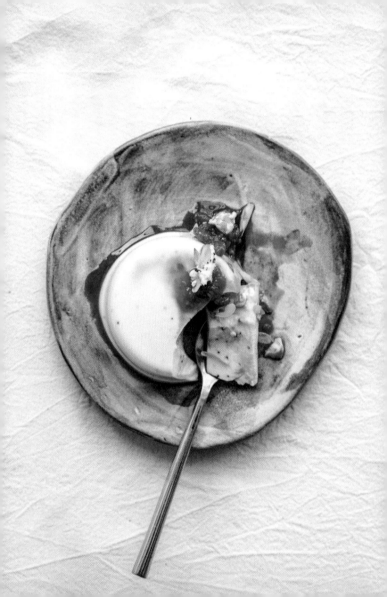

POISONOUS LOOKALIKES

Some of the plants in this book have doppelgängers which range from being mildly toxic to extremely poisonous. The illustrations below are designed to highlight some of the key differences between edible plants and their poisonous rivals, but use websites, other books and knowledgeable friends to help you too. Never eat anything unless you're absolutely sure you have the correct plant.

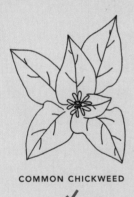

COMMON CHICKWEED
✓

SCARLET PIMPERNEL
✗

- Rounded, hairy stem
- Veins on leaf that branch off towards the sides
- White flower

- Square, hairless stem
- Veins on leaf that run vertically towards the tip
- Red or pink flower

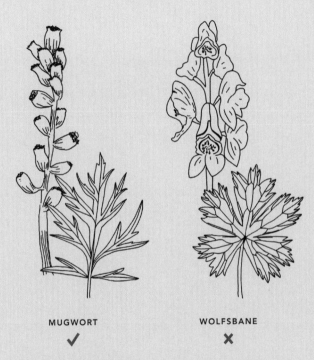

MUGWORT

✔

WOLFSBANE

✖

- Dark red and pale yellow
 flowers (wait until plant is
 in flower to identify)
- Leaves have silvery downy
 hair on the underside

- Purple hooded flowers
- Leaves are smooth on
 the underside

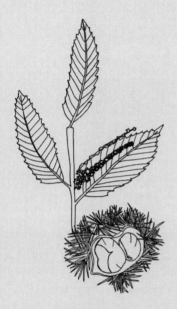

SWEET CHESTNUT

- Husk covered in long spines, sea urchin-like
- Drop-shaped brown nut with one flat side
- Long, serrated leaves

HORSE CHESTNUT

✗

- Smooth-skinned husk with intermittent short spikes
- Spherical red-brown nut
- Hand-shaped leaf made up of five leaflets

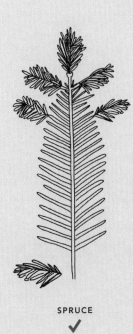

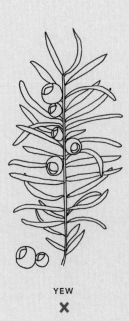

SPRUCE
✔

YEW
✘

- Firm, bright green needles
- Needles grow from all
 angles of twig
- Sweet pine scent

- Flat, flexible green needles
- Needles grow from sides
 of twig only
- Odourless

THREE-CORNERED LEEK

- White trumpet flowers
 with green stripe on petals
- Long, thin leaves
- Onion/garlic scent

LILY OF THE VALLEY

- White bell-shaped flowers
- Wide leaves
- Sweet scent

POISONOUS LOOKALIKES

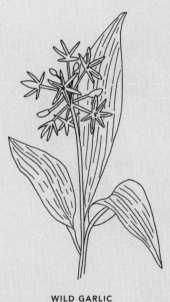

WILD GARLIC

✔

- This pair are not
 lookalikes but lords and
 ladies grows among wild
 garlic so be careful when
 foraging the latter

LORDS AND LADIES

- Arrow-shaped leaves
- Yellow leaf-like flowers
- Foul scent
- This plant produces toxic
 red berries in autumn

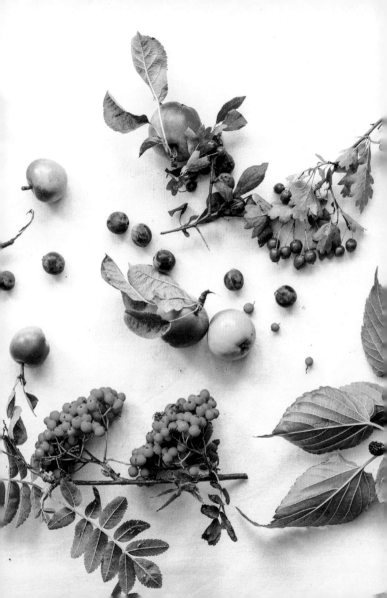

CONTRIBUTORS

WROSS LAWRENCE is a wild food forager who lives in London. He grew up in south-west Wales and has always had an avid interest in nature. Before foraging, Wross worked as a deep-sea fisherman and then as a tree surgeon. He has been collecting wild food for over 10 years and has picked for royalty, Michelin-starred restaurants, markets, veg box delivery companies, department stores, breweries and more.

MARCO KESSELER is a photographer whose work has been awarded numerous prizes and exhibited at photo fairs around the world. His clients include *FT Weekend Magazine*, *The New York Times* and *TIME*. When he's not out taking pictures, Marco is usually foraging for wild mushrooms or eating his way across London.

HOXTON MINI PRESS is a small independent publisher based in Hackney, east London. We sit in a small office overlooking a canal that reminds us of how much nature courses through our city. Our mission is to make artistic books that are both beautiful and accessible and which remind us of the richness of our urban lives. Thank you for supporting us.

The Urban Forager: Find and Cook Wild Food in the City
First edition, fourth printing

First published by Hoxton Mini Press, London 2020.
Copyright © Hoxton Mini Press 2020. All rights reserved.
Photography © Marco Kesseler*; concept, recipes and text by Wross Lawrence;
book and cover design by Daniele Roa; copy-editing by Liz Marvin
and Faith McAllister; production by Anna De Pascale; illustrations
on pp.184–189 by Becca Jones; recipe testing by Jenna Leiter.
With thanks to KANA London, whose ceramics appear
on p.99, p.171, p.179 and p.183.
*Except for image on p.156 © Ian Redding.

The rights of the authors to be identified as the creators of this Work have
been asserted under the Copyright, Designs and Patents Act 1988.

A CIP catalogue record for this book is available from the British Library.
ISBN 978-1-910566-69-5

No liability is accepted by Wross Lawrence or
Hoxton Mini Press for actions taken by the reader.

No part of this publication may be reproduced, stored in a retrieval system,
or transmitted in any form or by any means, electronic, mechanical, photocopying,
recording or otherwise, without the prior written permission of
the copyright owner.

Printed and bound by OZGraf, Poland

Hoxton Mini Press is an environmentally conscious publisher,
committed to offsetting our carbon footprint. The offset for this book was
purchased from Stand For Trees.

For every book you buy from our website, we plant a tree:
www.hoxtonminipress.com

FSC
www.fsc.org

MIX
Paper from
responsible sources
FSC® C163799